BY HISHAM MATAR

A Month in Siena
The Return
Anatomy of a Disappearance
In the Country of Men

A Month in Siena

A Month in Siena

HISHAM MATAR

For Corol of Mark,

Will but wishing

Mutan

Myc. 17.12.209

A Month in Siena is a work of nonfiction. Some names and identifying details have been changed.

Copyright © 2019 by Hisham Matar

All rights reserved.

Published in the United States by Random House, an imprint and division of Penguin Random House LLC, New York.

RANDOM HOUSE and the HOUSE colophon are registered trademarks of Penguin Random House LLC.

Published in the United Kingdom by Viking, an imprint of Penguin Random House UK, London.

LIBRARY OF CONGRESS CATALOGING-IN-PUBLICATION DATA Names: Matar, Hisham, author.

Title: A month in Siena / Hisham Matar.

Description: First edition. | New York: Random House, [2019] Identifiers: LCCN 2019026219 (print) | LCCN 2019026220

(ebook) | ISBN 9780593129135 (hardcover) | ISBN 9780593129142 (ebook)

Subjects: LCSH: Matar, Hisham | Authors, American—Biography. | Matar, Hisham, Travel—Italy—Siena. | Art—Psychology. | Painting, Italian—Italy—Siena.

Classification: LCC PR6113.A87 Z46 2019 (print) | LCC PR6113.A87 (ebook) | DDC 823/.92—dc23 LC record available at https://lccn.loc.gov/2019026219

LC record available at https://lccn.loc.gov/2019026219 LC ebook record available at https://lccn.loc.gov/2019026220

Printed in Germany on acid-free paper

randomhousebooks.com

2 4 6 8 9 7 5 3 1

First U.S. Edition

Design by Andrea Lau

CONTENTS

Duccio's Door	3
The Shape of a Room	11
A Landing Place	15
David and Goliath	26
Armor, What Armor?	39
The Bench	52
Evidence	61
The Museum Guards	70
The Blue Ribbon	74
Taking a Seat	82
The Problem with Faith	89
The Fire	103
Il bagno turco	108
The Angel's Predicament	115
Paradise	122
Image Credits	129

A Month in Siena

DUCCIO'S DOOR

AFTER MORE THAN THREE DECADES OF BEING AWAY I went back to Libya, the place where I grew up, the country of my origin, the setting-off place from where I had traveled, going further and further away. Returning changed how the past and future seemed. I felt compelled to write about it. Three years later I completed the book and emerged from that long period of concentrated work blinking into the light. It was then that I decided to go to Siena. I have for a long time been interested in Sienese art. But, now that I was finally going, my mind began to devise ways of delaying my arrival. It was as though the long years of anticipation had created a reticence. And so I complicated how I was to get there. As Siena does not have an airport, I considered flying to Florence and walking the 80 kilometers or so across the Chianti hills. I convinced myself of this on the grounds that I liked the idea of small steps covering a long distance and of finally entering the city on foot. But, a week before I was due to depart, I had, in an embarrassingly undramatic accident—in fact, by simply turning direction—twisted my knee. The pain was tremendous. When I asked the doctor how I could cause such damage by doing so little, he looked at me and said, "It happens." He then told me that I should definitely not undertake any long-distance walks. I regretted booking the flat in Siena. I had found it after only fifteen minutes of searching online and had already paid the deposit.

My knee had not fully recovered, but I made up my mind nonetheless to fly on the planned date. My wife, Diana, decided to join me for a couple of days. She was, in effect, delivering me there. She seemed to know better than I did my need for this trip. The only tickets we could find were on Swissair. I was born in 1970 and, even though we lived in Tripoli, most of the travel my parents did throughout my childhood was on that airline. I still associate it with adventure and reliability. But on our second leg, flying from Zurich to Florence, and just as we were crossing over the snow-capped Alps, with their dramatic ravines gashed deeper where the narrow streams of melted snow ran black, the airplane suddenly turned full circle and began traveling in the opposite direction. A few minutes later the captain spoke. He said that due to a mechanical fault we had to return to Zurich. No further explanation was offered. I calculated that it would have taken us forty minutes to reach Florence and now it would take about half an hour to return to Zurich. What could have possibly gone wrong for the plane to be judged unfit to fly that extra ten minutes? Diana held my hand. I made some joke about how nice it would be to spend a few days

in the Alps. She smiled cautiously and remained quiet. The plane was full and when it suddenly shook a little, some passengers could not help but let out a shallow murmur of panic. I heard a woman cry. Otherwise, everyone remained still and silent. I remember thinking I did not mind dying—that it would have to come at some point—but that I was not quite ready yet, that dying now would be a waste, given how much time I had spent learning how to live.

When the plane landed in Zurich, several of the passengers clapped. Diana and I had a tasteless lunch in the airport. The following flight did not get us into Florence till night. We went into town and had a drink and a bite to eat. We managed to make the last bus to Siena. We laughed about the saga, about how it had taken us as long to get from London to Florence as it would take to fly to India. The bus moved in the dark. It began to rain, and the rain turned monstrously beautiful, lashing the windows. In one of the curves the driver swerved violently and parked by the wayside, where he had spotted another bus that had broken down. The driver of the bus stood by the side of the road waving a torch toward us. Behind him men, women and children clustered under their umbrellas, their suitcases beside them. The drivers exchanged some words and some of the passengers from the brokendown bus began to climb on to our bus. As there were hardly any free seats left, they filled the aisle. Their clothes smelled musty and sweet from the rain. Several of us gave up our seats to the elderly. Then a loud argument ensued between the drivers: our bus could not hold any more passengers, and the driver of the other bus should have been more careful. When we resumed our journey, I saw that the front of the broken-down bus had completely plugged itself into the thick steel barrier that stood between the road and the drop. With every turn, we, the standing passengers, swayed back and forth as if performing a mournful dance routine.

At this point the whole trip seemed a terribly bad idea. Why had I been so determined to come? In 1990, when I was nineteen and still at university in London, I had become mysteriously fascinated by the Sienese School of painting, which covered the thirteenth, fourteenth and fifteenth centuries. I had lost my father that year. He had been living in exile in Cairo, and one afternoon he was kidnapped, bundled into an unmarked airplane and flown back to Libya. He was imprisoned and gradually, like salt dissolving in water, was made to vanish. It was shortly after this that, for reasons that still remain unclear to me now, I began to visit the National Gallery in London every day during my lunch break and would stand in front of one painting for most of the hour. Every week I would choose a different picture. Today, more than a quarter of a century later, having failed to find any trace of my father, I continue to look at paintings in this way, one at a time. I have found much profit in it. A picture changes as you look at it and changes in ways that are unexpected. I have discovered that a painting requires time. Now it takes me several months and more often than not a year before I can move on. During that period the picture becomes a mental as well as a physical location in my life.

I was in the early stages of this habit when I encountered the Sienese paintings. At first I did not know how to

approach them. They seemed, in their often symmetrical structure and direct gaze, to be an affront, a confrontation. They were foreign in ways that the other pictures I was interested in then—paintings by artists such as Velázquez, Manet, Titian, Cézanne and Canaletto—were not. These pictures from the Sienese School seemed instead to belong to a cloistered world of Christian codes and symbolism. I cannot say that they gave me pleasure. Yet I kept, almost against my own intentions, returning to them. I would often look quickly and pass. They left me feeling unprepared and in need of translation. They stood alone, neither Byzantine nor of the Renaissance, an anomaly between chapters, like the orchestra tuning its strings in the interval.

This curiosity has deepened over the past two and a half decades. The colors, delicate patterns and suspended drama of these pictures gradually became necessary to me. Every few months I go to the National Gallery in order to look once more at Duccio di Buoninsegna's The Annunciation or The Healing of the Man Born Blind. The seeing, who include Jesus, his audience and the version of the blind man now healed, sedately occupy the lower half of the painting. They are contrasted by the playful and brightly crisp activity in the upper half of the picture, where a hopscotch of arches and windows, peering into empty spaces, stare openly. They seem to be deliberately leading one's gaze away from the human activity below. It is in that direction, upward, that the second representation of the blind man, the one still visually impaired, is facing. It is a painting that is questioning and ironic about what it might mean to truly see. It is not definite about the answer. It has

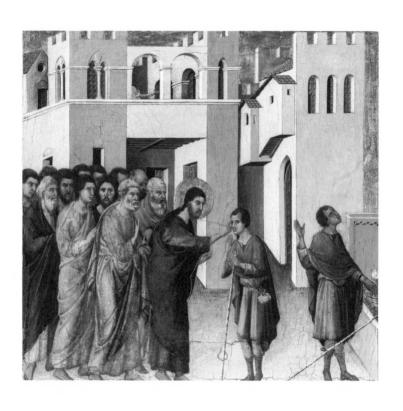

always, and throughout all the many years that I have been returning to *The Healing of the Man Born Blind*, seemed to be a space of doubt.

If I am away from London for any significant period of time, there inevitably comes the moment when I must search in the local museums for something from the Sienese School, preferably by Duccio, for, although he is not necessarily the most excellent, he acts as the source from which Simone Martini, the Lorenzetti brothers-Ambrogio and Pietro-Giovanni di Paolo and all the others flowed. The precision and particular generosity of Duccio's work opened up a door through which others could pass. This unveiling of new territory must be one of the most remarkable achievements that an artist can attain. By challenging the imagination they nudge our perception a little and, for an instant at least, the world is remade. This exchange of ideas between the artists who walked through Duccio's door is nearly audible. To look closely at their work is to eavesdrop on one of the most captivating conversations in the history of art, one concerned with what a painting might be, what it might be for, and what it could do and accomplish within the intimate drama of a private engagement with a stranger. You can detect them asking how much a picture might rely on a viewer's emotional life; how a shared human experience might change the contract between artist and viewer, and between artist and subject; and what creative possibilities this new collaboration might offer.

This is why these paintings seemed to me then, even from within my initial bewilderment, as they seem to me now, to articulate a feeling of hope. They believe that what we share is more than what sets us apart. The Sienese School is hopeful but also flattering, producing paintings that are confident of your presence, intelligence and willingness to engage. They are early examples of the kind of art that would later dominate, whereby the subjective life of the observer is required in order to complete the picture.

Over the last twenty-five years, the more fascinated I became with Sienese art, the more Siena began to occupy the sort of uneasy reverence the devout might feel toward Mecca or Rome or Jerusalem, and therefore I became, out of a skepticism about such pilgrimages, suspicious of my desire to visit the city. There were also practical concerns: given the depth of feeling I had for the place and the number of paintings there that I wanted to see, I would need to find the time for a long stay in the city.

THE SHAPE OF A ROOM

BACK IN THE EARLY 1960s SIENA BECAME THE FIRST Italian metropolis to restrict access to motor vehicles. The bus deposited us at the edge of the city. We pulled our suitcases into the dimly lit web of alleyways. The rain was now a drizzle and the black cobblestones shone darkly. The narrow streets made the houses loom over us. Their graving terracotta bricks were only vaguely perceptible in the night. The sharp turns of the passageways and the closeness of the buildings gave me the sense that I was entering a living organism. With every step I pressed deeper into it and, as though in response, it made room. I was inside a place both known and deeply unfamiliar. The flat I had rented turned out to be part of an old palazzo. It had frescoed ceilings and perfectly proportioned rooms. The modest exterior of the building made the beauty of these private spaces even more acute. Over the coming days, and whenever I left the house, I was often conscious, even without looking back, of the sober façade. It was like

an ally to whom I wanted to unburden all sorts of secrets. The place reminded me how the buildings we encounter, like new people we may meet, can excite passions that had up to then lain dormant. Most of the time we are not even aware of such adjustments. They happen mid-stride, and are often mutual, for, just as we influence and are influenced by others, the atmosphere of a room too is marked by what we do in it. And most of what we do vanishes, but a slight and shadowy remnant remains. How else then to account for why we can perceive awfulness where awful things have occurred, or be quietly inspired by a room where for a long time attention had been given to what is beautiful and kind. Every time I returned to the flat I felt my anticipation grow. And over the coming days, everywhere I went in Siena, I did, in effect, carry with me, like a private song, the pleasure of those rooms.

The play of understated exteriors and magnificent interiors, of calm serenity on the outside and deliberate care and thoughtfulness on the inside, of a modest or moderate face concealing a fervent heart, is a Sienese habit, a magic trick the city likes to perform. It does this not only out of the desire to surprise but also, I felt during those early days, to demonstrate the transformative possibility of crossing a threshold. We often never think of this, of how our sense of being is subtly changed by walking into even the most inconsequential of buildings or transitioning from one room to the next. In our age we have come to underestimate architecture by exaggerating its utility. We often think of buildings not as spaces where human life takes shape, but rather as sites for certain functions and activities. Siena resists this. It is as though the wall that

encircles the city like a ribbon is as much a physical boundary as it is a spiritual veil. It is there to keep out invading armies but also to keep in and intensify Siena's sense of itself. Independence here is not merely a political concern, but a spiritual and philosophical one, aligned with the sovereignty of spirit, with the right to exist in accordance with one's own nature as well as the need not to lose sight of the self.

Diana and I spent that first morning walking aimlessly. The twisting lanes meandered with their own secret purpose, governed less by a town planner's master plan than a spontaneous temperament. Or so Siena led you to believe, until you suddenly reach its crescendo, which lay at the kernel of itself, a square like no other: the Piazza del Campo, simply referred to by the Sienese as "Il Campo." This is where Siena reaches the middle of itself, where it pours out completely. But here also is its source. This is the end and the beginning, the location of the twin tides, declared in the open. And it was as though Diana and I had entered a space that was ours, one in which we had all along been anticipated and where, we suspected, once we left we would continue to be expected. Isn't this at least one definition of happiness, I thought, to be anticipated? But, of course, it was not ours alone. Here we had to keep our manners and perhaps even our wits about us. No matter where we were in the square, we were able to see the entire place. Not one person was hidden. This strange effect was made possible by Il Campo's unusual fanning shape and by the way the ground dips dramatically toward the long side where the civic and secular heart of the city, the Palazzo Pubblico, raises its tower high to compensate

for the hill and achieve its ultimate goal, which is to be the tallest building in the city, taller than any church. It was as if I had become, by simply walking into the square, an all-seeing eye. But, because I could see every person in the square, this meant that each of them could potentially see me too. It was a space of mutual exposure. Whatever it is that creates that elusive bond between strangers taking account of one another in a public space was present here but in such a criss-crossing of currents that the whole place seemed electrified. And so, although we had entered a recess, a sort of giant pit, Il Campo also appeared, like a lit-up stage, to be suspended. To cross it is to take part in a centuries-old choreography, one meant to remind all solitary beings that it was neither good nor possible to exist entirely alone.

A LANDING PLACE

During that first day in the city, Diana and I had one of those rare conversations, one whose beginning and end were not definite. It continued through countless turns and interruptions that appeared to be engineered by Siena, as though she were the silent but active third partner, conducting the dialogue. I remember thinking that this was one of the main functions of a metropolis: that cities are there in part to render us more intelligent and more intelligible to each other. I do not remember how we got on to the subject, which concerned freedom and assertiveness, their possible definitions, and whether the two were aligned or antithetical. We had carried the topic with us, for it started when we were on that bus from Florence, or perhaps even earlier on the plane before the pilot U-turned—I cannot remember—but I can vividly recall how it accompanied us during that first day in Siena, and so it feels, from this perspective, as though our exchanges over what freedom and assertiveness might be were the means by which we had entered the city.

We wandered into the Accademia Musicale Chigiana and stood looking up at the beautiful decorations on the ceiling of its courtyard. Through the use of false perspective a flat surface had been made to look like the inside of a dome with carved borders. Diana, who is a photographer, said that maybe what an artist wants—not only the one who painted this fresco but perhaps every painter and photographer across time—is to make a flat surface give way, to open up a space. As she said this, I pictured a man literally enter and escape into the fresco. We left and walked through the streets. Each drew its own shape. We talked about Islamic sacred patterns and how looking at them alone, being lost in their interlocking lines and formations, some believed, was like prayer. I thought it was odd that we should speak about this, as this was not a topic we often talked about. I then told her about how, growing up, I had a sensitive and quiet teacher who was unusually frugal with his words, but who told me once that, to him, looking at nature—staring at the sea, for example—was equivalent to praise.

We reached the Palazzo Pubblico. Before Italy became a country, it was made up of a collection of city-states, each governed by a monarch, privileging the influence of aristocrats and the Catholic Church. Siena was unique in that it favored civic rule. The Republic of Siena was created in 1125 and continued for the four hundred years that oversaw the flowering of the Sienese School. The city was a vibrant place for the economic exchange of goods. It profited from the agricultural success of the surrounding lands and became a banking center, making considerable

returns on its loans to the papacy. It was Siena's secular government that controlled the strings of power, enjoying a high degree of autonomy from ecclesiastical authority. It determined and collected its own taxes, made and imposed its own laws. The city was rich, well run and, by the standards of the time, democratic. The Palazzo Pubblico was its administrative hub. At the heart of the building is the Sala dei Nove, "Hall of the Nine," where the council of nine magistrates met to carry out executive functions and debate issues of governance. It is a rectangular room: approximately 8 x 14.5 meters. When we walked into it. we both turned about ourselves. In February 1338 Ambrogio Lorenzetti, a painter who had in recent years risen to prominence, was commissioned to paint a series of frescoes on three of its walls: two of the long and one of the short. The overall area he was required to cover including borders, which he decorated with patterns, text and medallions—is about the size of a tennis court. Lorenzetti completed the three frescoes in sixteen months. This was what we had come to see.

At the center of the composition, at the short end of the room, Lorenzetti placed his *Allegory of Good Government*, a hymn to justice. It is not only one of the earliest and most significant secular paintings, it is also the most adamantly so. If civic rule were a church, this would be its altarpiece. The eye struggles to find a center. There appears to be no anchor, no god, no place to rest. The activity is distributed in such a way as to frustrate the need for a singular authority. It instead presents a visual parade of a political manifesto: a series of figures facing us, arranged in a stacked procession, as though to demonstrate a principle.

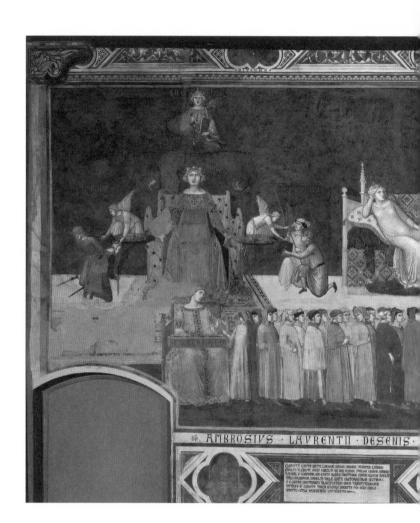

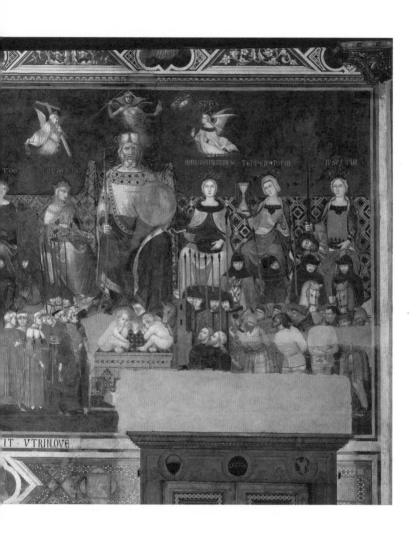

Words are philosophies. We have to assume that each is purposeful about its contradictions, that each word means what it says. The English word "demonstration" has at least two meanings; one refers to the public act of protest—to march, rally, declare or express an opinion—and the other is to do with showing, with making something manifest or apparent in order to instruct or display. The Arabic muthahara, the Persian tathaharat, the French manifestation, the Italian manifestazione and the Spanish manifestación—all, regardless of their variant linguistic roots, agree that in a demonstration there are at least these two sides: one concerned with making something apparent and the other with objection. Several other languages have come to the same conclusion. This seems to make perfect sense: one could argue that in order to protest one needs to make something clear. By the same token the need to exhibit is an act against oblivion, a resistance to emptiness; that art and death exist at opposite ends of the spectrum.

One of the ways to read Lorenzetti's frescoes is as a demonstration, in both senses of the word. They denounce and praise. The middle one, the *Allegory of Good Government*, is keen to instruct and make bluntly clear the hierarchy of the Virtues and their relationship to power. Like an illustration of a psychological drama, it is organized on several horizontal planes. On the highest level, Wisdom, Faith, Charity and Hope float suspended, their wings working and their heads nearly touching the ceiling. Below them, occupying the central plane, are the larger and more prominent Virtues seated on either side of the Common Good, represented by the dominant figure of

the old man with the white beard. To the left sit Justice, Peace, Fortitude and Prudence; to the right are Magnanimity, Temperance and Justice. Justice is therefore repeated; she brackets the picture. Behind these Virtues is the blue of the heavens, the color of deep water where all manner of things could be submerged. On the bottom, however, where common citizens, magistrates, troops and prisoners stand, the earth is dark and messy, a browngreen that has aged into a complex stain, like an unsteady memory that persists only through the haziest of recollections. Diana and I spoke about it and one of us compared it to a threadbare carpet. In fact, like an old rug, this whole picture appeared to have been worn thin by time. There was an imprecision in its tone that made it seem uneasy or reserved about its intentions. And this was a feature of the whole cycle of frescoes. So, although they were blunt and insistent about their ideas of what constitutes good and bad governance, the paintings also had a reticence that they seemed to have accidently and unintentionally earned over time.

At first glance, the structure of the Allegory of Good Government, with its triple procession of Virtues and citizenry, seemed to have been arranged at random, but then after a few moments I realized that what I was looking at is a circular painting. It wants to keep your eye constantly moving. This is why it starts and ends with Justice. Lorenzetti, being so fascinated by literature, by language and narrative, intended for us to read his fresco from left to right, and then not to fall off the edge but rather be turned back again in a perpetual assessment. Perhaps this is ultimately what every painter wants, I thought, to keep you

contained within the boundaries and to offer you a sort of rare freedom that only comes from limits. He meant for us to start with the first Justice, where she dominates the left section of the painting, as though in a space all her own. She is solitary, concerned with balance, its problem and necessity. She rests one thumb on each round golden plate of the scales. Her job obviously requires great delicacy and precision but also an air of defiance and indifference. Her eyes rise above in pointed detachment. It is as though, she seems to be saying, the scales of justice are by design balanced, that justice is the established condition, the normative state in which, free from corruption, all things will eventually find their true equilibrium, as though composure is the natural shape of things. All that Justice has to do, then, with the help of Wisdom, who hovers above, holding the scales' central column, is lend a gentle hand to reinforce and calibrate that universal order: the right side, where an angel oversees the exchange of goods between two tradesmen, is concerned with fair commerce; the left, where an angel crowns one citizen while slicing a sword through the neck of another, with reward and punishment. From each pan runs a thread down to the lower tier, where Concord, the conveyor of harmony and the leveler of differences, is seated with a carpenter's plane. She twists the two threads into a rope and passes it on to the council of citizens, twenty-four men who stand in a line, passing the cord to the Common Good. Among these men no two faces are the same. They are indeed so distinct that they seem to be portraits of people Lorenzetti knew or else well-known public figures from the time. Either way, the painter intends to convey a broad catalogue of personalities: the calculating, the somewhat indifferent, the bored, the assenting, the wayward, the suspicious, the flatterer and the flattered, the dispassionately optimistic, he who is encouraged and he who is aware of the honor and is humbled by it, the other who is made focused and keen and full of intention, the concerned, the mildly overwhelmed, and the nonplussed, who seems to be going through the motions. It is as though the fresco is arguing that the criticisms proffered by the detractors of democratic rule—the system's exaggerated confidence in the variance of human nature, its overreliance in matters of the common good on the unreliably mysterious inner lives of ordinary individuals—are exactly its strength.

My eye was drawn to a man standing close to the head of the line. He seems contained in his own thoughts, confident about where he finds himself yet also taking account of it. He appears to be thinking about the distances he has traveled—something about the way he is standing conveys this. And, like his manner, his features too are foreign. He is the only one wearing a patterned and short gown. It shows his legs, which are, like his face, darker than those of the others. I remember reading about a prominent Sienese family of the time who were originally Arab. They used a moor's head as a charge on their heraldic arms. This was rare then but soon to become common practice among European noble families who traced their ancestry to Muslim Spain. The Arabic Sienese family was named Saraceni because they were regarded as Saracens, which was how Italians then referred to Arabs. Perhaps this dark-skinned man is a Saraceni. I wondered how he felt about the occasion and whether he was now more rooted in his adopted country. Perhaps Lorenzetti added him in order to advocate this system of governance on its merits of tolerance and inclusion.

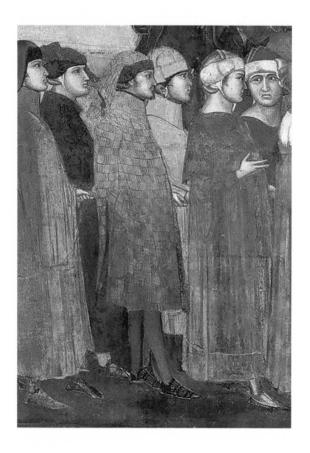

Each man has got the rope Concord has woven, passing it up the line but also grabbing on to it as though for support, till it reaches Common Good, the large figure above, enthroned on the seat of state. The rope is wrapped around his wrist, therefore binding the figure of Common Good,

through the citizenry, to Concord, Justice and Wisdom. He stares ahead in an expression of grave responsibility, as though holding his breath or worried about losing his balance. He also appears to be caught in a dream, or locked inside an aspiration. On the right sit Magnanimity, Temperance and the other Justice, who, unlike the first, is not administering the law but rather exhibiting the consequences of its judgment. She is holding her sword up vertically, the butt of its handle resting on a man's severed head that lies in her lap. In her other hand she is holding the empty crown that, presumably, the dead man had once worn. There is a strange correspondence between Justice's face and that of the executed man. The resemblance is in their expressions—peaceful yet troubled—as if they were old lovers who, after years of living together, had begun to look alike

DAVID AND GOLIATH

The likeness of Justice and of the decapitated head resting on her lap reminded me of another painting that Diana and I had seen a couple of years earlier, in Rome. As we stood in the Sala dei Nove, impressions from that day returned to me with peculiar vividness. We had been to see Caravaggio's David with the Head of Goliath in the Galleria Borghese, then wandered through the streets in silence, together but each occupied by our own thoughts. It was late spring. The Roman sun was out. Around noon we looked for shade. Diana spotted a green beside the Sant'Andrea al Quirinale. We lay under the canopy of a high pine. The grass was cool and accepting against my back. My head was now lower than my chest and I could feel the blood gather between the temples. Diana lay beside me, resting her head on my chest. I remember getting that odd feeling, a sort of mystery toward my own anatomy, not entirely certain of what was contained beneath my ribcage. I felt then what I felt now standing in the Sala

dei Nove: that an independent will operated these secret clocks inside of me, that the operations and very texture of my organs and the blood that ran through them belonged to some other order of existence that stood apart from my sense of my self, from my ideas and emotions.

"I have such a beautiful perspective," Diana suddenly said.

I continued looking at the canopy of the pine tree stretching above, the blue sky beyond it. I did not wish to be distracted from my view or try to imagine another. Besides, it was impossible to know hers, to see exactly what she was seeing. It would always be an approximation. My mind went to a conversation I had recently had with an old friend back in Tripoli, where Diana and I had spent some days just before going to Rome, about how "Desire, its continuum, is reliant on yearning, on the unfulfilled wish, the frustrated appetite." As my friend spoke, he and I walked at night through the city of my boyhood, some of its buildings damaged by the recent revolution and the civil conflict that had followed it. I was, in other words, back in my old and known city and yet finding myself in an entirely new and changed place. "Desire," my friend continued, "dies the moment it achieves its end. What keeps our passion for anyone or anything alive is the promise of attainment. In other words," my friend continued with that air of confidence that I had not always tolerated during our youth, but that I now cherished, "there is a contradiction between what desire wants-complete conquest-and what it needs in order to continue to exist: mystery, the unknowable. Desire is that animal that remains fit only through undernourishment. In evolutionary terms, failure is its prerequisite, frustration its generator."

As compellingly delivered as it was, I had misgivings about my friend's thesis, but I was taking too much delight in his enthusiasm, in his abstractions and exaggerations to mind. And hadn't we always done this in our childhood. spent hours slinging pebbles at the stars, knowing full well that, even before we fired them, the stones would fall right back and probably on our own heads? And isn't this the way one must surely live, for all time; that the true pleasure is not in hitting the target but in aiming at it? So I sought to encourage my friend further in his ruminations on the nature of desire by recounting to him a scene from Joseph Conrad's The Secret Agent. Adolf Verloc's cover is blown. The secret political agent's wife, Winnie, confronted with her husband's true identity and the tragic consequences of his actions, which have caused the death of her younger brother, is inconsolable. Her "equable soul," as Conrad describes it, had been knocked off kilter, and the sentiment, which up to this point she had felt profoundly, "that things don't stand much looking into," is no longer sustainable. The truth, at once horrible and unavoidable, stifles Winnie. She does not ask questions. She neither rebukes nor inquires. She is acting out of pure pain, but perhaps also strategically, knowing that engaging her husband in any way stands the risk of consolation. Instead, she becomes impenetrable, a blank page, and this bewilders Verloc greatly because, "Curiosity being one of the forms of self-revelation," Conrad writes, "a systematically incurious person remains always partly mysterious."

It is a moment of deep desire between husband and wife, perhaps the most passionate one in the whole novel. It is when Verloc realizes that Winnie's unquestioning nature, which had helped him conceal his true identity from her, has also been working on him, making him, strangely, more in need of her. My friend, not being familiar with The Secret Agent, wanted to know more about the book. We were, or so it seemed that night in Tripoli, old childhood friends who, after three decades of being apart, of communicating only through telephone and letters, then email and text messages, were now sharing, with the fullheartedness of rescued stowaways or vagabonds, what precious stones the years had gathered in our pockets. He vowed to read the book and I vowed to get him a copy. I did not tell him how the novel ends; I said nothing about the tragic fall of Verloc, the man who, after living a double life, still believed he could be loved for himself.

The distance between where we stood now in Siena, in front of Lorenzetti's Allegory of Good Government, and that moment, a couple of years before, when Diana and I had landed in Rome from Tripoli, in the wake of my momentous return to my country after more than three decades of exile, a period of time in which I became a man and perhaps a different kind of man from that other one I might have been had I remained in Libya; and the hours after seeing David with the Head of Goliath in the Galleria Borghese, searching for shade and finding a place to rest under a pine on a green beside the Sant'Andrea al Quirinale—all seemed to fold together and collapse like a concertina of days made of the same fabric. Here we were

in Siena, Rome and Tripoli all at once; and here we were looking at the faces of Lorenzetti's Justice and her victim, as well as those of Caravaggio's David and Goliath.

I remembered how on the grass in Rome I had touched Diana's hair, which had fanned out behind her and across my chest. And I remember how strange it was then to think that she had no way of knowing that my fingers were in her hair. I thought of our time in Libva, of when we had stopped, just like this in search of shade, under the Arch of Marcus Aurelius in Tripoli only a few days before. I remembered how, when we had finally come away from the white sun and into the arch, the shade felt surprisingly cold and wet and Marcus Aurelius's words, words which I had forgotten or neglected up to then to recall, had come to my mind—"Love this to which thou returnest"—and for a moment I thought of speaking them out loud but then, for reasons I still do not know, I did not. On that same day in Rome, as we lay on the grass, poets were gathering under the Arch of Marcus Aurelius for Libva's first International Poetry Festival. I should have gone, I thought to myself looking up at the pine tree. Why am I not there? Yet somehow there was the odd conviction that I was in the right place, that here was the center of my life, lying with Diana on the green next to the Sant'Andrea al Quirinale. She was breathing long and calmly but I knew she was awake, looking at the view above, which had probably changed a little as she shifted to make herself more comfortable, or had deepened, as it became more intimate. I felt grateful for knowing her for so long, for sharing my waking and sleeping hours with her for nearly half of my life, for being loved for myself and able to love

her for herself. It's the sort of gratitude one can never express. It certainly can never be spoken and possibly not even written.

I wondered how this picture, Lorenzetti's Allegory of Good Government, appeared to her? I thought of what she had said in Rome as we lay on the green: "I have such a beautiful perspective." She has said these words, or words similar to them, before in other cities, but how appropriate, I thought now, surrounded by Lorenzetti's political purpose, to have said them on that day in Rome, not only because on that same day thirty or so poets from around the world were gathering in Tripoli and so my mind was constantly veering there, but also because we had spent most of that morning in the Galleria Borghese standing silently in front of Caravaggio's David with the Head of Goliath, looking at the curiously tragic, almost regretful expression on David's face as he considers his prize, the mammoth, clumsy and bodiless head he is holding at the end of his outstretched arm, as though worrying he might dirty himself, the giant's hair almost slipping through his delicate fist. Goliath's old eyes stare into the distance: shocked, doubtful, as if caught inside a dream or, the opposite, woken up by death from the sedative cycle of the days. Whatever it may be, he is looking at something we cannot see and have never seen. We are looking at David look at Goliath—this is clear—but what remains unknown and unknowable is what Goliath is looking at. Goliath is now outside the range of our experience. And this makes everything else—the past and the future and, not least of all, David himself—less secure. David feels this acutely. We are watching him understand and resist a new

truth: that revenge had given Goliath the edge; that the moment you execute your enemy he escapes and slips into another dimension where he can see more than you can; or, that in the absence of an afterlife, their biography has closed and therefore is no longer alterable. This must be why tyrants prefer to imprison and keep alive their most ardent adversaries. They know that, like Goliath here, the dead's last argument is their silence. Why else does David's face hint at remorse? Perhaps killing Goliath had earned him a new sympathy. It is not that Caravaggio's David regrets his victory, but rather that the magnitude of his act, the scale of his accomplishment, of extinguishing another man's life, has become for him, and perhaps for the first time in his young life, clear and conceivable. He finally knows what it means to kill a man.

Caravaggio's David, very much like Lorenzetti's lady Justice, is both acting and remembering his actions in a faraway place. Given war's trap, that one of the two sides must lose, David, as well as being David, must now also become Goliath. He must be both killer and killed. By removing his enemy, he must now contend with how to fill the gap, the empty space where once stood the body of Goliath. And perhaps this is why the dark practice of decapitation has returned in recent years. I wonder if, beyond the obvious motives of a beheading-to deal the enemy a final blow by separating their head from their body and therefore not affording them a dignified burial, to make a prize and an example of the fallen, to dislocate and fragment a person's body in the hope that that would disfigure their ideas, beliefs and memory—there may be, lying beneath all these, a deeper desire: that, besides being

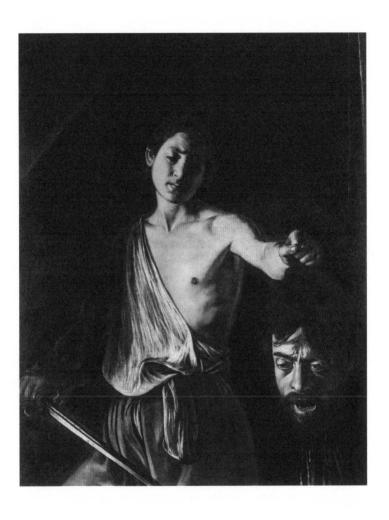

an act of final punishment and desecration, a beheading is also an expression of the private impulse literally to take the place of one's adversary; to carry their head above and occupy the place where their body had once stood, to walk where their feet had once trodden.

Nicolas Poussin understood this. In his The Triumph of David, which hangs in London's Dulwich Picture Gallery, he depicts David entering Jerusalem carrying with some effort on a thick wooden stick the heavy head of Goliath. Poussin opts for a theatrical scene. His David is wet lipped and naive, surrounded by the admiring and the curious, as well as by those caught unawares: one mother sheltering her children behind her back, another excitedly encouraging her boy to look on. Like an incredulous young athlete, Poussin's David has yet to stomach his unlikely victory and its implications. Held high above him, Goliath's gray face is both that of the captive but also of the captivated, for he appears to be, in the silence of his death and in the inner gaze of his large shut eyes, caught in the throes of some deep feeling, some terrible but noble dream. And the way Poussin chooses to position David's and Goliath's heads—one on top of the other; or one, David's, seeming to have emerged from inside the other, Goliath's-further advances this hypnotic correspondence between the two men. It is as though they are both one and the same person but at different points in his trajectory, or that they are, perhaps, father and son.

By contrast Caravaggio's David stands alone. His business with Goliath is a private affair. Nothing but darkness surrounds them. This is the intimacy of adversaries, which is equal in its intensity with that of lovers. David's blade,

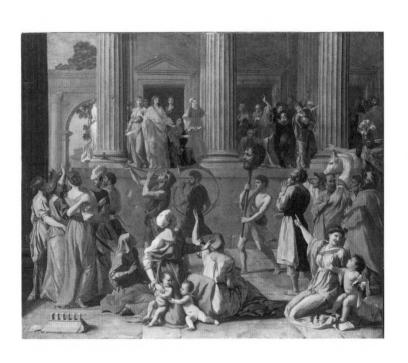

lean and clean and shiny, rests on his thigh, just below the groin. Why? What is that detail supposed to mean? Why the close proximity between David's blade and David's penis? Perhaps at the moment of murdering Goliath. David fathomed the extent of his desire, had understood the true scale of his own passion, and that something about this had unsettled him. Perhaps the moment he ended his opponent's life, David was overcome by the temptation, now forever thwarted, to try to see things through Goliath's eyes. Perhaps at that moment David understood the fault: that, because of the adamance of our beliefs and passions, each one of us must live restricted by his or her own perspective. And that this has something to do with redemption, that our redemptive instinct is found in our unequivocal sympathy for our enemy, and that to be a man is to live in the constant unresolvable tension of these two poles.

Away from the extremes of enemies, a similar desire exists between friends and lovers, perhaps more intensely between old friends and old lovers. Maybe my desire to see the green beside the Sant'Andrea al Quirinale or Lorenzetti's fresco or Caravaggio's painting or life itself through Diana's eyes is the expression of my hunger to achieve, in the words of my Tripoli friend, "complete conquest" over her and to resolve, once and for all, the mystery of her consciousness; but perhaps it is not that at all, but rather the expression of my redemptive instinct, my unequivocal sympathy for her, my desire to be inked by her and therefore momentarily escape the confines of my own existence. Only love and art can do this: only inside a book or

in front of a painting can one truly be let into another's perspective. It has always struck me as a paradox how in the solitary arts there is something intimately communal. And it suddenly became doubtful to me as we lay in Rome, as indeed it was now standing in the Sala dei Nove in Siena, whether I would have written anything or could ever write anything if I had never loved. Implicit in the act of creation is praise, of discovering and naming the world, of acknowledging it, of saying it exists. The French artist Henri Cartier-Bresson had once described taking a photograph as saying "yes," not the "yes" of approval but that of acknowledgment. In the end, as it is in the beginning, love and art are an expression of faith. How else to function with the limited knowledge we have? Asked if he was a pessimist, the English playwright Edward Bond replied: "Why am I talking to you if it is not a gesture of hope." Lorenzetti's Allegory, Caravaggio's David and indeed the entire history of art can be read as that: a gesture of hope and also of desire, a playing out of the human spirit's secret ambition to connect with the beloved, to see the world through her eyes, to traverse that tragic private distance between intention and utterance, so that, finally, we might be truly comprehended, and to do this not in order to advocate a position but rather to be truly seen, to be recognized, not to be mistaken for someone else, to go on changing while remaining identifiable by those who know us best.

Lying on the grass in Rome, Diana placed a hand on my thigh and sat up. Her back suddenly seemed an extensive and sweeping geography in the luminous and open day. The places where she had been—my stomach and chest, the spot on my side where her hand was resting—all felt cool and exposed.

"What a beautiful place," she said.

I came up on my elbows. I feared she might stand up and say, "I'm thirsty" or "What shall we do next?" or "Come on, let's go."

She looked out at the people passing by. Someone had been watching us all along: a man, about my age, sitting on a bench on the opposite side of the green. I wondered how we appeared to him. Perhaps Diana too was thinking the same. But then she lay back down again and her body found the exact places where it had been before. And in that moment this seemed miraculous.

ARMOR, WHAT ARMOR?

THAT FIRST NIGHT IN SIENA I HAD A DREAM THAT I WAS directing a feature film in a city by the sea. I had gathered the crew by the main promenade at the edge of the unknown city to shoot an important scene. I could feel the presence of the big metropolis behind me. The sea was deep and voluminous, its surface rippled. There was nothing interrupting its horizon. I thought of taking a swim and the next moment I found myself undressing. No one seemed to mind. I climbed on to the short wall and dived. As soon as I was under water I regretted my action. I had not even checked if there were steps out. What if I cannot find a way to get back on dry land? When I rose to the surface and looked back. I saw that I had drifted far out to sea. The city was now the horizon. My rapid heartbeat was not only in my ears but seemed to run all the way down into the depths and fill them. I felt as if I were wasting away, leaking into the water.

Later that morning I took Diana to the bus station and

stood watching her face behind the glass window until the coach pulled out. I missed her immediately. And here was my solitude, as quick and thick and heavy as always. It was temporally rich, as though when one is alone time becomes a room with double windows: one looking into the past, the other into the future. The historian's temptation is to capture the uncertain past, to contain and divide it into chapters, ages and epochs, to organize and tell the story coherently, to locate and make an inventory of its motives and outcomes. And we are, of course, each one of us, the historian of our own lives. The future, on the other hand, provides endless opportunities for our predictions and fantasies. With it we can indulge our optimism by planning the years ahead, as though time were a carpet one could roll out into the unknown. The past and future stimulate our imagination; the present overwhelms it. What is there to do with this ongoingness that neither pauses nor tires, this ceaselessness that is like a blinding light flickering so rapidly that the naked eye cannot perceive its reverberations? The seconds are not divided, as a clock would have us believe; time does not tick, but is welded in a seamless progression. Talk of "being in the present" or "living in the moment" has become part of our contemporary language. But the present offers no options; it insists on our attention. It is relentless and knows that everything is contingent on it. The most casual turn, an innocent encounter-with a person, a book, a painting, a piece of unexpected news-or a mere thought passing through one's head can leave one ever so slightly altered. And somehow we know, as the minutes pass, that we are being quietly made and that there is nothing we can do to stop it,

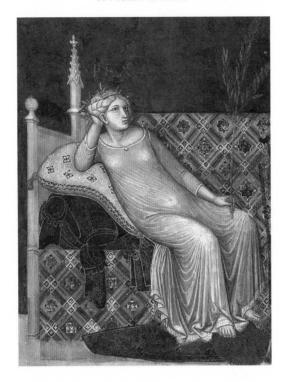

because, when it comes to the present, we are susceptible and enthralled. By comparison the past is more easily locatable, or at least we have concocted the illusion that it is, and the future, no matter how uncertain, always seems distant. It is the guest who is forever not quite yet here.

I walked back into the folds of the city, one street following the next, losing my way without concern. What is it like to be born here, I wondered, and what is it like to die here? Those twin questions have followed me into every city. I have learned to make use of them. They have become part of the logic of my thinking, of how I engage with a place. I am never oblivious to where I am, and how often I have wished to be.

I returned to the Palazzo Pubblico. It was odd to be back in the same rooms but without Diana. If I stop and think of the people closest to me, of where they might be at this exact moment, what they might be up to, how they might be feeling, what might be preoccupying their thoughts, the weight of their concerns, I become incapable of doing anything else. It is a truly debilitating state. It fills me with immeasurable anxiety, sorrow and longing. I have never understood why the basic fact of the lives of those with whom I am intimate running concurrently and separately from mine must fill me with such darkness.

I stood in front of Lorenzetti's Allegory of Good Government again. This time the picture seemed to still and settle. to be fixed in place by a structural order that I did not notice the first time. It was as if my eyes had been reeducated by the painting or perhaps by Siena or even by the dream of the sea I had had the previous night. To the left of the figure representing the Common Good sits the Virtue Prudence. She is pointing to an object, perhaps a water clock, that reads "Past Present Future." Beside her is Fortitude and then, reclining languidly in a sheer white dress, there is Peace. She resolves the picture, offers it a center, a place for the eye to land. She is why this room, the Sala dei Nove, is also known as the Sala della Pace, "Hall of Peace." She is, it now appears, the organizing principle: both of the rest of the activity in the fresco and, by implication, the proposed system of governance. This is partly because of where Lorenzetti has placed her and partly because of her expression: waiting, monitoring, listening, her hand shelving her open ear, which is pointed toward us. Beneath her feet, as well as buried under the cushion on which she

is resting her arm, are black bundles. It took me a moment to realize that they are pieces of armor, denoting how in the presence of peace there is no need for battle. But the detail is oxymoronic: armor, a thing used for protection and concealment, is itself being concealed. There is also something comically slapstick about how Peace seems to be pretending that nothing is there: Armor, what armor?

Covering the longer walls on either side of the painting are even larger frescoes, running the entire 14.5-meter length of the room. The Effects of Good Government and The Effects of Bad Government: one simulates how the world would appear if the advice of the central fresco were followed and the other how it would be if it were not. In The Effects of Good Government a just, prosperous, peaceful and harmonious city is shown to exist side by side with a thriving and verdant countryside. The metropolis, with its interwoven and variant architecture, is teeming with color, amiable sociability and unprejudiced trade. The landscape is depicted with a sweeping lucidity, rich with astutely observed details and an informal freedom that would not look out of place among modern paintings. There is a wide array of plant life, handsome people upon handsome horses, healthy donkeys bearing abundant loads with a weariness that expresses a gentle and loving gratitude, as though their burdens were actually their own offspring. There is a fat and wholesome pig; delicately keen and joyful dogs ever so affectionately rendered. The city resembles Siena; this is natural enough, but also accentuates the feeling that, when you are in it, Siena comes to seem like the only city, or the city that is every city, or not a city at all, in fact, but an allegory of a city. The farms too correspond to those of the

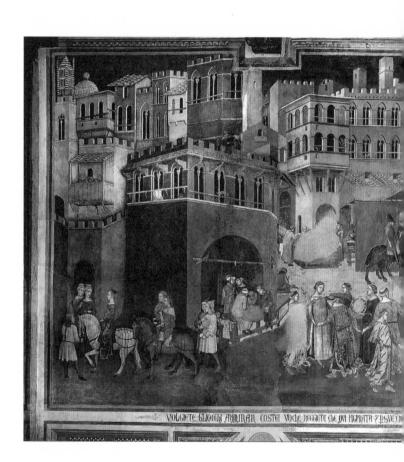

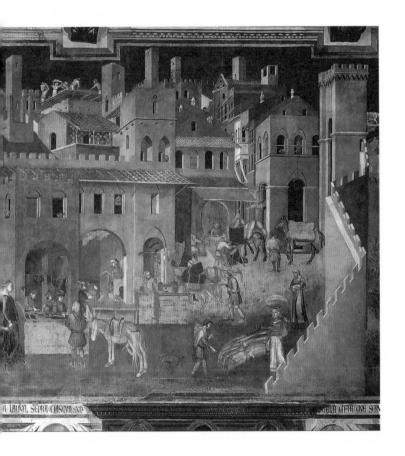

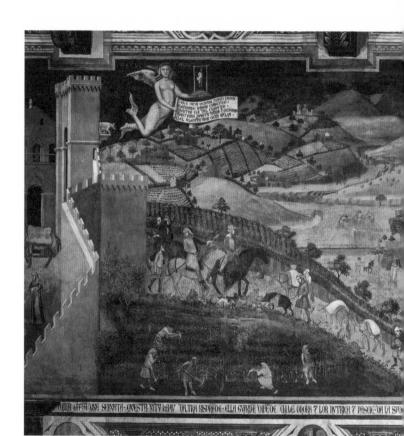

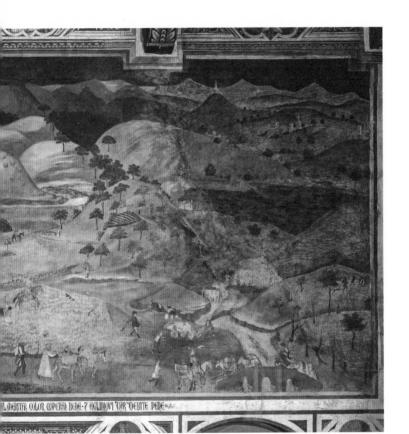

surrounding rolling hills. The dividing wall, running vertically, splits the painting in two. The decision is so assertive, juxtaposing human creation and nature in a way that is striking. Looking at it you can almost detect the air changing between the two halves. Both regions are benefiting from the fruits of good governance.

The fresco facing it—The Effects of Bad Government shows Tyranny reigning and Justice in chains. Tyranny, portrayed as an androgynous devil, reminded me of the graffiti that covered walls everywhere across Tripoli, caricaturing the fallen Libyan dictator Muammar Qaddafi. Here too Tyranny is meant to look vile and stupid, and here too he is darkly mesmeric: cross-eyed, with horns and braided hair, a permanent frown clinched on Dracula teeth. He is without doubt. He is relentlessly fixed on his intention. And this makes it hard to take one's eyes off him. He dominates the entire room. He captivates. I could imagine the magistrates who had, over the centuries, met here in the Sala dei Nove in order to discuss the welfare of the citizenry, the distribution of taxes, the threat of invading forces and other matters of state, being occasionally drawn to his portrayal. Above Tyranny are what Siena's magistrates deemed the "leading enemies of human life": Avarice, Pride and Vainglory. On the left sit Cruelty, Deceit and Fraud; and, to the right, are Fury, Division and War.

Unlike the Allegory of Good Government and The Effects of Good Government, both of which are to be read predominantly from left to right, the normative direction for a reader of Latin, The Effects of Bad Government is to be read from right to left. Here the city is as hard and empty and naked as a flexed muscle. The only business that seems to

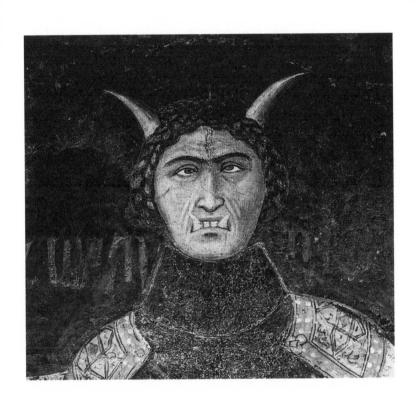

be thriving is that of the armorer. Houses are abandoned, their windows left wide open, and others crumbling from war. Further in the distance, two armies are facing one another in perpetual combat. Justice, chained at Tyranny's feet, has been dethroned and stripped of her gown. All she has got is her white chemise. It wraps itself around her like a second skin, as though the fabric too is embarrassed. Time, or a vandal, has erased the section running from just beneath her breasts all the way to her upper thighs. A grayish cloud now covers that area. It is as if age has breathed smoke over Justice's reproductive system.

I left and was in the expanse and openness of the square. It was near noon and the whole place was in the light. I lay on the brick tiles of Il Campo, polished by centuries of pedestrians and horses and carts. I could feel the warmth of the ground seeping into my back. I listened to the random conversations around me. I wished I could speak the language. My father could. I saw his face, the only one I knew, the one before his captivity, when he was well and free. Then I remembered how on one occasion he spoke to me in Italian—only two or three sentences—his eyes smiling, enjoying my inability to understand him. I was baffled by his attitude, by the fact that I could not read him, by how stonily impenetrable his thoughts seemed. I wished I could remember what he had said—for, although I still could not speak Italian, I could partly understand it now. My father often traveled alone. He never, it seemed, had a problem about his own pleasure. But at that moment, lying on my back on Il Campo, the sky open above me, I felt I had exceeded him, that the pupil had excelled his teacher.

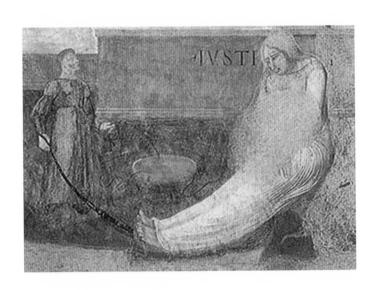

THE BENCH

The following morning the sun shone and I went out early. This is the time when I would usually write, and yet I had no sense of obligation that day. Every time I finished a book I felt emptied by it. But I had never experienced this more severely than on completing my last, the one on my return to Libya and my failed search for my father. I sat opposite the Duomo, its facade blinding and icing white in the light. The square was empty. An elderly black woman walked across it. We greeted one another. She sat beside me, a polite distance away, and began talking in Italian. Quickly perceiving my handicap, she spoke with that generosity of outsiders, uttering each word clearly, gesticulating and looking me straight in the eyes. Her voice echoed easily against the buildings and the stone-slab floor of the vacant piazza, which, with no soul in sight, appeared uncertain in scale, as though it could have been significantly larger or indeed smaller than it was. It seemed both a grand space and yet one as intimately private as a courtyard. What I gathered from what the woman told me was that she was originally from Nigeria and that she had been living in Italy for twenty-three years and was now, finally, eligible for a passport. She pointed to a grand building to one side of the square.

"That's the ministry," she said.

"What will you do when you get your passport?" I asked.

"Visit my country," she said, and in the silence that followed she repeated, more to herself, "Yes, my country."

Something about her made me think of my mother.

I wanted to go to the Pinacoteca, the museum that houses several of the paintings I have, for so long now, been wanting to see. Lying in bed the night before, just before I fell asleep, I felt that rush of excitement I recognized from childhood, when knowing with trembling certainty that as I lay in bed the sea was still there and would continue to be there throughout the night and the morning too when I would wake up. I had fallen asleep imagining those paintings in the darkened museum rooms of the Pinacoteca. But now, in the early morning, sitting in the square beside the woman who had been waiting nearly for as long as I have been wanting to visit Siena, close to a quarter of a century, to return home, I felt it was not yet the right time to go to the paintings. I waited with the Nigerian lady until the ministry opened. I wished her luck. She placed a hand on my cheek and thanked me. Her skin felt cool and dry. We embraced and I watched her until she entered the building.

I walked on and watched the city wake and busy itself. I followed several individuals from a distance. I told myself that I was undertaking this strange and disreputable activity in order to see how locals navigated Siena, to catch a glimpse of their daily lives, to live, as it were, in their wake. But the truth was simpler, more bodily than intellectual, more to do with rhythm than ideas. I simply wanted, like a stonemason grinding his chisel on a rough slab, to sharpen myself against the city. I followed a man to his place of work. From about 15 meters away I trailed a woman and her young boy. When they arrived at his school, she stood a long time watching him through the gates until he entered the building. She remained there for a minute or two, looking up, presumably, at the window of his classroom. I followed her to another address and left when she entered an unmarked building.

That day Siena was to me as intimate as a locket you could wear around your neck and yet as complex as a maze. It completely shielded me from the horizon. My compass could only be guided by it, by its twists and turns, its maneuvers and decisions, by its tastes and purposes. Siena is its own North Star. And, as it is the case that those who are jealous are to some extent invested in control, Siena too seemed to me that day to be anxious about my freedom and fidelity. I had never been anywhere so determined, so full of intention and so concerned about my presence, for, no matter which way I turned, the city seemed to be the one determining the pace and direction of my walks. There and then I believed I could spend a lifetime here in this foreign city where I had, for so long and for some mysterious reason, longed to be.

It was still not the right moment to go to the Pinac-

oteca. I returned to the flat, ate and slept a little, then spread the map on the small table that stood between the two windows. I decided, in order to keep new my sense of the city. I would walk every day to one of its boundaries, leave through one of the city gates and then, once I had lost sight of Siena, return to it again. By the afternoon I left the map behind and wandered out toward the southwestern edge. The streets narrowed as though each were defending its own territory. One after the other they descended out into the periphery, fading. I was now by the city wall, looking out on to a vast landscape. The openness seemed strange and marvelous. In these few days since my arrival Siena had already succeeded in making my eyes unaccustomed to the horizon. I suddenly felt I understood, and could see from Siena's point of view, that infinity is a claustrophobic prospect, that it is perfectly appropriate, given the chaotic nature of life, to cordon off an area in which to interpret ourselves, where one can decide what is important, what is to be privileged and what to be left out, determine the axes of the main thoroughfares and the arrangement of streets between them. And somehow these boundaries seemed to be a circuitous acknowledgment of nature's power, its freedom and confidence, its enthusiasm for the light, its openheartedness. I looked out at the cypresses and olive trees, the metallic light on the hills. The air was luminous and moist, and the sky glowed as if licked with a porcelain glaze. I stood there for a long time. All about me was silence. Then a couple of schoolchildren approached—one on his mobile phone, reporting his day at school, and the other with his head down as he struggled up the hill with a heavy rucksack on his back. More children appeared behind them, some with parents and others unaccompanied. They were all leaving the large, square building at the bottom of the hill. I wished I knew a family here, as the company and conversations of children, I thought, would surely help me to improve my Italian, this language I can just about understand but feel an impediment to speak. Then I heard a man talking in Arabic to his young boy and girl. He looked my age and his face was like that of people I had grown up with. I said hello in Arabic. He stopped, greeted me and seemed both surprised and a little amused.

"Where are you from?" he said.

"Libya, and yourself?"

"Jordan." He had arrived in Siena thirty years ago, he told me.

That was the same period of time I had spent in London, I thought.

His hair was black and curly, like mine would be if I let it grow. His name was Adam.

"My loves," he said, speaking to his children, "Kareem, Salma, greet your uncle Hisham."

They smiled and extended their small hands.

"Do you need help?" he said. "Anything at all?"

"No, thank you," I said.

"Are you here for work? Do you need help with papers, visas and such?"

"No, no," I said, smiling.

"Really, I know the place and can take you around, help translate. Do you speak Italian?"

"I don't, but I understand a little."

"Then I can go with you. I have a car."

"You are so kind, but really I am fine. I am just visiting. I have always wanted to see Siena, to see the art."

He looked at me as though, having judged that I was hiding my true purpose, he was resigned to my privacy. His daughter, Salma, was looking at something in her hand, but Kareem was following our conversation, turning his head from his father to me as we spoke. Now the boy looked at me and smiled. His father pointed up the hill.

"See that street over there," he said, "the one with the church? I am Number 90. My name is on the doorbell. Anything you need, consider me your brother here."

Although such sentiments are not uncommon in Arabic society, Adam's words moved me; I had no doubt, from his eyes, his face, his entire demeanor—and also from the kindness of his children—that he meant every word.

"I wouldn't think of bothering you," I said. "But perhaps we can have a coffee sometime?"

"Take my number," he said and asked me to read it back to him. "Excellent," he said. "Now give me a missed call."

He took out his phone and we both stared at it until it lit up. He immediately registered my number, writing down my name in full. We said goodbye. He walked up the hill, Kareem and Salma keeping up a faithful trail behind him.

I walked in the opposite direction. Something about the encounter, how at once effortless and unexpected it was, made me optimistic about my time here. I continued walking down the hill. I wanted to be inside the landscape, to find a way out of the city, to cross all the new buildings that now encircle Siena, and enter the hills and stand among the trees Lorenzetti painted. I went out of the city wall and the sound of the air changed, becoming open and hollow, like when, having pressed your hands tightly on your ears, you release them. Now there was no shade and I felt the sun warming my back. Eventually, at the end of the road, I reached a dead end. There was a gate through it. I entered and found myself inside a cemetery. It was the size of a small city park.

Most of the headstones had a photographic portrait of the deceased and sometimes two: one when young and another near the time of death. Several of the dead were buried beside their spouses, who, it was more often than not the case, followed them a year or two later. Some of the dead had passed away decades ago, and several over a century past, yet it was clear that their descendants still visited, for the graves were carefully maintained and fresh flowers brought to them. The women on the headstones looked familiar. Theirs were the same concerned faces of the women of my childhood, and of that Nigerian woman I had met earlier in the Piazza del Duomo: faces that worry, faces that are unsure of the prospects. And it seemed to me then that these Sienese women suspected, when their picture was taken, that the captured image would outlast them. They look at the camera with wearied compliance. I was deeply affected by them—and it somewhat surprised me.

An avenue, lined with high cypresses, cut through the graves. There was a bench on it. I thought of taking it, but then continued. I passed a couple walking slowly arm in arm toward the exit. They quietly wished me a good evening and I, also in a soft tone, returned the greeting. I

remembered how I liked cemeteries, their seriousness and formality, that in them one is always encouraged to speak softly and sparingly. I went to the limit, hoping to find a view of the open country, maybe even a passage into it. I did not expect what I saw. It turned out I had all along been in the old part of the cemetery, a small area by comparison with these vast terraces I was now looking down at: battalions upon battalions of headstones. The scale was unfathomable. It is one thing to consider the particular intimacy of a single grave, another to glimpse death's endless appetite. The deceased outnumber the living. The present is the golden rim of a black cloth. How outrageous it is to be alive, I thought. It filled me with such enthusiasm and dark pride for my race, for how brave and heroic we are in the face of the undeniable evidence that life cannot be maintained, that regardless of what armor we choose, all things must pass.

I continued walking toward the new end, or the end I now could see. When I reached there I could touch the olive trees on the other side of the low wall. They were young and silver in the light. I could have easily climbed over and stood among them, but for some reason I did not. I imagined bringing friends here. I pictured not telling them where we were heading, engaging them instead in a conversation about a completely different topic so as to have them stumble upon the cemetery very much as I just did, not out of the wish to unsettle them, but rather to share with them the same sense of discovery. Then I thought what a terrible idea that was.

Suddenly I felt someone was standing right behind me. I turned and found a bench tucked away, facing the land-

scape. It had the last of the sun and an unusual aspect, one private but yet with an open, panoramic view of the country. A good place from which to look out, I thought; a good place to hide; a good place to cry. I sat down and hoped no one would ever remove this bench; that it would remain there till the end of time. To one side there were three large stone basins. Water for flowers.

EVIDENCE

I SIGNED UP FOR AN ITALIAN-LANGUAGE COURSE. IT WAS good, I told myself, for my head, suffering from that ardent and melancholy liberty of being between books, to be employed in learning. And for the following days every morning I would walk to the school, climb up to the top floor and sit in a classroom for two hours. The room was of average size but with a very high ceiling. It had only one window, not very large, and it looked on to another window of a similar size belonging to the building opposite, like two faces silently regarding one another. The window across the way had well-tended flowerpots lining its sill. Laundry hung on a clothesline beneath it on most days. Intimacy in the open. The brightness of daylight meant that that window, shut or open, revealed very little of its interior. There is nothing like learning a new language to remind you how agile and fluent the eye is and how unwilling and clumsy the tongue can be. Halfway through my third class, as new words flew at me in quick succession, I felt overwhelmed and nearly ran out. It was as though I had hit a wall. It passed; I must remember this, I told myself.

I was released at noon, my head aching, not entirely clear why the experience was so troubling. Perhaps learning a new language is a reminder of when we were unable to say anything at all, when we did not have the means to communicate that we were hungry or cold or simply bewildered, and some of that distress must remain and is enlivened by occasions of inarticulacy. But it must also be my own specific experience of having been obliged to immigrate, at the age of eleven, from my mother tongue, Arabic, to English. And if you have done such a move once, any further disruption can come to represent a mortal danger.

The teacher, Sabrina, whom I immediately liked and quickly came to call, without even asking her permission, Sabri, not only because that was the nickname I had heard one of her colleagues call her by but also because of the district in Benghazi of which I am fond and that has the same name, and also because the Arabic word sabri is the possessive form of "patience"—as in "my patience." She was from Calabria, which is nearly as far from Siena as it is from Libya, and therefore we immediately felt the alliance of those from the south, a division and demarcation that is real and powerful in Italy. She took me out walking. I was the child asked to describe every action: "Stiamo scendendo le scale" ("We are going down the steps"), "Sto aprendo la porta" ("I am opening the door"). She took me to the farmers' market. Such lovely and distinct faces, notable for their characteristics and for how much they resembled those in the paintings I had been looking at: long straight noses, dainty mouths and eyes. Afterward we sat at a café on Il Campo in the sun. We spoke about Bertrand Russell and Ludwig Wittgenstein, in whose works Sabri had specialized when she used to teach philosophy of mathematics at the University of Siena. She pointed to a temporary structure on the square that looked like a shack.

"Una baracca," she said.

Hearing the familiar word amused me. I had up to then assumed that *baracca* was a uniquely Libyan word, meaning "hut" or "kiosk." It is, instead, one of several Italian words—such as *tuta*, *marciapiede* and *cucina*, for example—that made their way into the Libyan dialect during Italy's three-and-a-half-decade colonization of the country in the first half of the twentieth century.

"It sells *frittelle*," Sabri continued, "balls of rice flour with orange peel that are fried and then covered in sugar. The *baracca* will stay only for the month of March," she added. "Until the 19th." Then after another silence she said, "Here the 19th of March is Father's Day."

I was momentarily silenced by the coincidence. I then heard myself say, "Frittelle for the father. What a lovely idea." I did not tell her that I had lost my father in the month of March. I did not tell her that I had recently come to the end of my search and had still not found him. I did not even tell her that I had lost him. Then, not knowing what to say, I asked, "What of your father?"

She did not respond. I could not see her eyes behind the opaque sunglasses. She bit her lower lip. I decided to say nothing.

"He died exactly a year ago," she finally said and cried

quietly. "I'm sorry," she whispered. "I don't know why I'm crying."

"Tell me about him," I said.

"He was lovely and smart. He had committed to memory the entire volume of Dante's *Inferno*," she said.

"How awful for him," I said.

She laughed.

We spoke more easily now, and about less important things. Then we sat in a silence that seemed touched by an oblique sort of sadness, as though time itself were a burden that had to be carried doubtfully and with a quiet show of regret in case fate might decide to double the load. We said goodbye.

I walked around the city for a long time, then sat in the local café with a beer and a copy of the day's newspaper, which was starting a series of articles about the violence in my country, stating how, if I had understood correctly, "Even the United States acknowledges the importance of Italy's role in planning the West's operations against ISIS in Libya."

I went home and found a missed call from Adam, the man I had met by the school on my way to the cemetery. In my phone I had listed him as "Adam di Siena." I called him back. After we exchanged greetings he asked if I would agree to our being "informal" with one another from now on. I was taken aback by the request, both by how odd but also how genuine it was. We set a time to meet the following day. I was to visit him because, "Why have a coffee out when we can have it in the comfort of my home?"

I went to buy groceries to make supper. Many things

here were familiar to me: the way people are with one another, their open affections, the tied-up dried chillies, the biscuits with fennel seeds that are identical to those of my Libvan childhood, the discretion with money, the pride about one's home and food, the elegance and warm formality of some of the women, the cocky assuredness of some of the young men, the determined elegance of the older ones, the way some middle-aged men look at me and we exchange glances of recognition and mutual appreciation, the hours after lunch, the sounds and the silences and the sounds of silences, the sex on the surface of everything, the vulnerability, and the way cheeks redden, and the fact that the woman I buy the newspaper from, the baker and the greengrocer all stop me when they see me carrying my shopping home to ask what I am planning to cook and how I will make it, and are keen to contribute their ideas.

My phone has on it the thousands of hours of music that I have been collecting over the years. I connected it to the stereo in the flat and put it on shuffle while I cooked. I was going to prepare the purple baby artichokes, which were in season, the way the greengrocer suggested: cut the hearts in two and slowly cook in olive oil, garlic and butter; add salt and black pepper but only toward the end, two minutes before serving, "Otherwise you mask their flavor." The first track was a piano étude by György Ligeti. It was followed by Lotfi Bouchnak singing "Irtigal" in a live performance in Berlin. Then Hamza El Din playing the oud with unhurried determination. Now a Chopin sonata from a Martha Argerich recital. Francesco De Gregori singing "Niente da capire." A rare recording I forgot

I had of an old Bahraini pearl divers' work song. It was recorded onsite by a French ethnomusicologist in the 1960s. You can just about hear the sea in the background. I pictured the bare-chested men lining the bulwarks of the small open wooden boat, with the Frenchman and his microphone in the center, as they rose and fell with the water. There is something fervent in their voices. They sing for good fortune, they sing for endurance and valor. But when their voices eventually rise they rise with their adoration of God. I had forgotten how affecting it was. Then suddenly I could hear Diana speaking clearly, reading a passage from her book, Evidence, a photographic monograph in which she shot locations where Libvan dissidents had been interned, tortured or assassinated, catching in photographs what evidence remained in the atmosphere of these places where terrible things had occurred. I did not know that I had it on my phone or how it got there. I knew the text well and had no intention of revisiting it or what it contained, but I was struck by the lovely surprise of my wife's voice, how beautifully clear she sounded, how each word was enunciated with such tender precision and a quiet passion, as though she were whispering it in my ear or, more accurately, into the ear of the man she never got to meet and to whom the text is addressed, my father:

Your wife has lived here alone for most of the past twenty years. She has the custom of moving the living and dining areas each few months. Every time I visit the configuration is slightly different. But with each of these moves there remains a chair, a place setting ready for you at the head of the table, awaiting your return, as if by a miracle you will walk through the door. I imagine you light and agile, placing your keys by the door, greeting the maid with respect. I imagine men pausing in conversation, waiting for you to speak, and your wife making sure things are the way you prefer, your salads well seasoned and fresh, your shirts ironed, your papers left undisturbed.

I drive to the outskirts of the city, into new roads built since you were taken. Your first grandson, my nephew Jaballa, who is named after you, has come with me. We walk together over dunes, he carries my tripod before I ask and points out shadows in the sand, knowing my eye is tuned to that kind of thing. He takes the camera from my hand, teasing me, holding it high above his head and just out of my reach; he is getting taller now.

My husband has found a tissue in one of your old coat pockets, something that should have been thrown out but because you are gone it's treasured. I am afraid to touch it. I photograph it, wanting it to be more than what it is, to evoke your presence, yet all I see in the developed image is a tissue, crumpled and old. I throw the photograph away.

My husband and his brother have the same long, lean feet, the second toe longer than the first. I know it must be you, because their mother's foot is flat, with soft, plump toes that descend, each one shorter than the one before. I look up at your books, kept straight on the shelves; they are cared for, dusted religiously but not opened or read. There are

things that cannot be held in a man's library. I wonder what it would be like to know that part of you that led other men; and had you succeeded, how you would have handled dissent. I wonder how you would call my husband's name?

One day I return from the desert. Tarik, your second grandson, is taking apart the old stereo amplifier. Everyone in the family says he out of all the grandchildren is most like you. He has always been my favorite, something I tried but failed to hide. He dismantles the turntable into countless small pieces which cover the floor. I am afraid he will get bored, leave them for others to pick up, but he painstakingly cleans every one and then puts the stereo back together again. He plugs it in. It works—no static the volume is just right. Your wife takes the microphone and begins to sing and then abruptly stops. Her eyes tear then she speaks. The first thing she says is, "My husband is Jaballa and he was taken. He has disappeared." She says it as if there is a large audience, but there is no one in the house except us her grandsons and daughter-in-law-to hear her amplified voice.

I listened to it all the way to the end, not once interrupting the various tasks that were involved in the preparation of my meal. More tracks followed: Sviatoslav Richter, Maxine Sullivan, Shahram Nazeri, John Coltrane. When the food was ready, I switched off the music and did not feel like eating. The artichokes and the little pasta I made now appeared as though they had been in-

tended for another man. I thought of going out for some fresh air but my legs felt tired, my entire body seemed empty of will. I sat down in the armchair and fell asleep for a few minutes. When I woke up, I did not know where I was. Then I served the food without reheating it and ate in front of the television. One channel was playing clips from Tripolitania, a documentary shot in 1939, when Libya was still an Italian colony. The old footage showed Italians on the streets of Tripoli dressed in their Sunday best. Even in a black-and-white film I could recognize that bright tenor of Tripoli's light, washing out everything it touched, erasing figures and objects from view. The camera focuses on a young Italian boy playing war games, loading and firing imaginary rockets while his plump face frowns theatrically. He is so earnest in his efforts to appear menacing. I wondered what became of him. In his white shirt and black tie he looks like a clerk of some sort. His hair, severely combed to the side, shines when he moves as though it were a black helmet. There is a small chance he is still alive today, I thought. The historic footage was followed by a round-table discussion between Italian commentators talking endlessly about the current troubles in Libya. There was little critical engagement with the issues, just the sentimentality of history and the sentimentality of the present.

THE MUSEUM GUARDS

THE GALLERIES IN THE PINACOTECA WERE MOSTLY EMPTY Occasionally tourists, or a teenage couple, not letting go of one another's hand, would appear and wander through at such speed that it was possible, without much discomfort, to hold one's breath till they passed. The only permanent human presence was that of the museum guards. They were nearly all women and seemed to share something essential, as though they were part of the same mental body, connected by the same emotional thread. Maybe it was their solitude that made them seem this way, or perhaps all museum guards, no matter how quiet or busy their galleries may be, feel themselves to be alone, standing or sitting down, usually by a threshold, spending their working days observing rooms that are constantly emptying, where people come just before they go on to some other attraction or to lunch or simply to resume their lives. Has it not always seemed that these figures, and across national divides, in all the museums around the world, share the same private grievance, as though they have been let down by the rest of us? They strike me as spiritual beings, guardians standing at the gate of some nebulous but significant transition. And maybe this has allowed them access into what, to the rest of us, remains veiled, a truth that concerns the violent nature of our distractedness. Maybe this, regardless of the rising attendance figures that management keeps boasting about, and that the museum guards can see with their own eyes, has nonetheless convinced the guards that they are aboard a sinking ship. Their faces, their lethargic bodies, seem to belong to souls that have been burdened with an impossible task. They know, better than anyone else, that they could never fully protect the paintings, that we, the public, will steal them away not by literally taking them off the walls and running out with them, but rather through the most passive of gestures.

I had never before perceived this more acutely than in the Pinacoteca. My first afternoon there I simply did not know where to start and so went around quickly, spending a few seconds in front of paintings that took months and sometimes years to complete, and God knows how long to conceive, and have survived six, seven or eight centuries of human drama and natural disasters. I did not assume that the ladies who guarded the galleries had an interest in these pictures—they are certainly not obliged to—but at the very least they must have had a self-interested enthusiasm for them, not only because their livelihood depended on them but also because these paintings are their sole companions and so, whether aesthetically appreciated or not, must have become over time part of their lives, in-

volved in their sense of worth and their experience of reality. Their relationship to the art may or may not be scholarly, but it is certainly practical. And I have a confidence in the physical presence of things—much more than in intellectual abstractions. I believe an object in a room can exact an influence that is not contingent on whether the inhabitants of that room engage with it or even pay it the slightest attention. Montaigne was right in believing that the mere presence of his books around him had an effect on his mind and character, that their patient availability made certain thoughts and modes of thinking possible or more likely. I had no doubt it was the same for the museum guards at the Pinacoteca.

I left there at mid-afternoon. It was a beautiful day, the sun out and the sky as open and clear as my childhood sea, the southern Mediterranean, used to be on calm days. I bought some *frittelle* from the *baracca* on Il Campo and walked. I wanted to hear birdsong, and so I thought to return to the cemetery, to watch the gentle motion of the cypresses and to visit the dead, the old folk of this city, strangers all.

Soon on entering the cemetery, when I thought I was the only one there, I spotted a family: a man, his wife and their daughter. They were bent over and working diligently, cleaning a headstone, watering the flowers around it. The daughter looked about twelve years old. I had perceived something of her quiet affection toward her parents. It was as though the shape of her posture were saying, "I know I'm doing the right thing and I'm glad I'm doing the right thing." I saw all of this in a fraction of a second because the instant my eyes fell on them something made

me look away. I felt, in Gerard Manley Hopkins's phrase, I had to take custody of my eyes. I hoped they did not see me, the mourner without a grave, heading to his secret bench that was tucked away but that had an open view of the valley, to sit for a few moments and listen to the birds. I knew then that I had come to Siena not only to look at paintings. I had also come to grieve alone, to consider the new terrain and to work out how I might continue from here.

THE BLUE RIBBON

I BOUGHT A BASKET OF FIGS AND A COUPLE OF CHILDREN'S books and walked to where I had first met Adam. From there I continued uphill, in the direction I had seen him go. followed by his children, Kareem and Salma. I turned by the church and looked for Number 90, as he had told me. At the building's entrance there were at least twenty doorbells, each made of polished brass with a name holder beside it. I searched up and down the list more than once and still could not find his name anywhere. I wondered if I had misremembered the house number, but then there it was, midway down the first column of doorbells. I pressed it and nothing happened. I pressed it again and waited for about another minute. I thought of calling, but then decided to take a short walk instead and return in half an hour to try again. After all, I was dead on time. But before I reached the end of the street I heard my name and saw Adam walking quickly after me.

"I'm sorry I'm early," I said.

"You are not early. I should have warned you," he said, "about how long it takes to walk up. It's a large building and we are right at the top. No lift. None of the buildings in Siena," he said, taking my arm and walking beside me, "have lifts and so we all must lend a hand with groceries, particularly for the old folk." He took a deep breath and said, "I'm so glad you've come."

Inside, the building was dark and the air cool. He led me down a long corridor. My eyes had not adjusted to the shade and so I could hardly make out where he was leading me. I could just about see the decorated wood beams that lined the high ceiling. I could hear the laughter of children, then saw Salma running after her brother around a light-filled courtyard. Being a year or so older, Kareem found no difficulty in evading her grasp. He was delighted each time she got close. He would let out a giggle that I would come to know as his special laugh, a sort of quick succession of gentle but sparkly crackles, as though joy were fanning a fire in him. They ran over and took turns shaking my hand, their faces red from running, and seemed pleased to see me again, which surprised me, given that they were children and therefore had yet to perfect the tricks of social pretense. We climbed up several flights, Kareem and Salma alternating places so that he could be ahead and then she would run up and sneak past him. And sometimes they both reversed direction and ran down. The flat door had been left ajar. We entered a long rectangular room. On one side there was a large dining table with eight chairs; on the opposite end a bookcase with a

large television in the middle of it. Between these two ends a sofa and armchair were placed against the perpendicular wall, which faced the open kitchen. The television was on, tuned to an Arabic news channel. An elderly man sat in the armchair, looking sideways at the television, a cigarette burning between his long, lean fingers. He did not notice us walk in. Adam introduced me to his wife, Noha, who was cooking in the kitchen. She greeted me with genuine and uncomplicated warmth.

"I warn you," she said, "you will be eating what we normally eat; so don't expect much."

When I showed some resistance to staying for dinner, Adam said, "Stay and eat with us," and when I didn't immediately reply he added, "Let's have coffee first and then you can decide. Come, let me introduce you to my dear father." Adam placed a hand on the old man's shoulder and, raising his voice, shouted, "Darling Dad, this is our friend Hisham Matar from Libya."

The man looked at me, mildly startled. Then his eyes softened. I sat down beside him. He embraced me and I kissed his forehead.

"Welcome, my son," he said.

I did not know what to say. Then I asked him how he was.

"To be honest, not so well," he said. He spoke with some difficulty, stuttering each word with great effort, and in the gaps between these prized utterances his eyes wandered and peered out, as though hoping that something there, in mid-distance, might come to his rescue.

Adam sat on the other side of me, so that I was now between son and father. He said softly, "He had a stroke

but he's doing better now." Then to Kareem, who had brought over one of his favorite books and was in the process of showing it to me, Adam said, "Isn't that the case, Karami?"

I liked this unusual variation on the name. The name "Kareem" means "generous" but the word shares the same root as *karama*, which means "honor" or "dignity," and therefore this possessive form Adam had fashioned for his son's nickname—Karami—which I had never heard before, ingeniously means "my generosity" or "my dignity" or, a third possibility, a combination of the two.

"Isn't darling Granddad doing better since he arrived to visit us?" Adam repeated.

Kareem nodded, then walked into his grandfather's arms and smiled openly as the old man kissed him in the neck. Salma followed, as though it had been agreed that such affections would be allotted equally. Kareem was now standing beside me, his hand on my knee, looking with me at the book he had handed to me.

"What's it about?" I said.

"A cat," he said and hesitated. Kareem's Arabic was basic. Every so often he would look at his father and say the word in Italian. "A cat who loses her way and gets up to a lot of trouble."

"Is it nice trouble?" I said.

He smiled, looked at his father, then replied, "Yes, very nice trouble."

"I'm very pleased you like books," I said, "because I brought you one." I handed it to him.

Noha called out from the kitchen, "What do we say, darling?"

And Kareem uttered the common words of gratitude. I asked the boy if he could help me to better understand Siena. "For example," I said, "how do these *contrade* work?"

I had read about the seventeen contrade, the wards or districts that make up the city, each having its own mayor and administrative body and municipal budget. They compete in the Palio, the horse race that takes place every year on July 2 and again on August 16 inside the Piazza del Campo. I had witnessed on one of my walks a group of teenage flag-bearers cloistered in a dead-end created by an alleyway bending sharply upon itself, practicing for the parades that take place before the race. The drummer, whose march I had heard from a few streets away, was keeping a solemn and steady beat. His friends paced slowly in and out of a circle while turning their flagpoles in a sweeping loop, causing the fluttering silk to ripple and swell. Then suddenly they tossed the poles vertically, high into the air, where the fabric fell, as though made frightened and alert, around its pole. I was close enough now to hear the wind whisper around the banners. The boys often missed and the flagpoles clattered against the cobblestones, but that did not seem to get in the way of their trying again. I did not stop for long, as there was something about the spectacle that seemed private. Mauro, the head of the language school, used to be a flagbearer when he was young. He too had spent months practicing. He told me, with a joyful face, that his contrada, Torre, had won the July race the year before. He described how this ancient event, the Palio, remains the central event in the city. "The whole year is organized around it." When I expressed a distaste for the lack of sportsmanship involved, of

how, for instance, it is permitted for riders to whip one another and do all manner of unspeakable things in order to win, Mauro simply looked at me and said, "But the Palio is not a sport; it's war." He went on to explain that, although he too finds the violence and corruption that often surround the race unpalatable, he believes it serves an important purpose in the city. It is, according to Mauro, the main reason why Siena is exceptionally safe. "I cannot remember the last time a person was mugged or stabbed here. I think it is because we have found a way to funnel all of our madness into two days in the year. The Palio is a theatrical war, a display of battle that is really a celebration of coexistence." He explained to me that the people of each contrada, who, as well as being part of an administrative body, regard themselves as part of a tribe-like social structure and feel a sense of pride toward their streets. "They protect them and help the vulnerable, often carrying the elderly or the disabled who can't take the steps."

Kareem looked at his father. Adam answered on his behalf: "At first, we never paid the subject much attention, but then when Kareem was born we returned from hospital and found a blue ribbon tied to the main door downstairs. I had no idea what it meant and so ignored it. A few days later the Mayor of our *contrada*, together with drummers and boys carrying silk banners, came asking for Kareem. They said they wanted to baptize him." Adam laughed. "I told them we were not Christian, but they insisted, said it had nothing to do with religion. I told them no thanks all the same. But then the Mayor came and climbed all the way up here to our apartment. He said, 'Don't worry, it isn't a religious ceremony. We simply

want to welcome him into our area. We do this for every child born here. A blue ribbon for a boy, a pink one for a girl. Please come and if, at any point, you or your wife don't like what you see, you can take Kareem home.'"

As Adam was telling me this, Kareem went and fetched a large tube of paper from the bookcase and carefully released the blue ribbon fastened around it. He unrolled the thick cotton paper. It was covered with careful, precise calligraphy. On the top it had the *contrada*'s coat of arms and on the bottom, at the center, Kareem's name in full, with the Mayor's signature below. "That's the certificate," Adam said. "It was a crazy party. They paraded Kareem in the streets, celebrating their new member, and then the Mayor wrapped him in the flag of the *contrada* and spoke a few words, addressing the infant directly. He said that from now on they would look after him, that wherever he goes this will be his home."

Kareem looked proud.

"So does this mean," I asked Kareem, "that if, God forbid, I were to do something that would upset you, you would go and tell your *contrada*? Will I be beaten up?"

He giggled sweetly and when I repeated the question he shook his head and said, almost to himself, "No, it's not like that."

I had arrived at Adam and Noha's home at 7 p.m. and did not leave until 1 a.m. The whole evening was so natural and delightful that it felt, and we all had commented on this, as though we had known each other already and were simply picking up where we had once left off but without, as Noha put it, "the tiresome business of needing to catch up." And everything we discovered about each other's

lives unfolded spontaneously and without suffering the demanding weight of questions. I learned many facts about them—about their lives back in Jordan, how they came to be married, the life they had created for themselves in Siena—but it was not those things that remained with me most vividly but rather the quality of their lives together, the atmosphere they had created in their home, the unpretentious authenticity of their curiosities and the kindness of their human feeling. I walked home that evening holding this to my chest as though it were a precious object I had been given.

TAKING A SEAT

The museum guards at the Pinacoteca began to take notice of my visits. They registered how long I spent in front of some of the paintings. One day, after a few minutes of looking at a picture, I felt the hard edge of a chair being nudged against my calves. I thanked the guard and tried to explain that I preferred to stand, that there was something about being able to move, to go closer, walk back, that was necessary. She would not hear of it. One of her colleagues joined her to tell me that it was a good idea. "We have seen you stand for long periods," the other one said. From then on I resigned myself to taking the folding chair along with my ticket every day, carrying it in the sling of my arm from one painting to the next. I became very dextrous with the chair. I would lean on it like a cane, sit on it the right way and sometimes the opposite way, with my chest against the backrest, or sideways, as though I were sitting on the terrace of a café. The chair—and it was always the same black, wooden, folding chair—became a sort of companion. I was glad for the guards' intervention; I was now able to spend even longer in front of a picture. "Didn't we tell you?" one of them said. It also made me more familiar to them, which meant I became easier to ignore. It was then that I chanced on the mysterious habit that several of these museum guards shared. Alone and at certain hours of the day, when the galleries were empty, they would stand facing one of the windows that overlooked Siena's terracotta rooftops, which, cascading this way and that, resembled, on cloudy days, a dark cubist painting and, in sunny brilliant weather, a brightly shimmering mosaic, and I would hear the museum women guards speak into the windowpanes. They spoke softly and fluently as though engaged in an actual conversation. At first I assumed that they were on their mobile phones. But then I discovered that they were actually talking to themselves. They would stop the moment another guard or visitor appeared. It pleased me that they felt comfortable enough to forget my presence, not least of all because it made it easier for me to forget theirs and remain focused on the paintings, which were the third party, of course, with their own silences and various conversations

After my first excited and somewhat bewildered tour of the Pinacoteca, I spent the following few days mostly looking at the *Madonna dei Francescani*, a painting that is the size of a private letter. It is thought that Duccio painted it sometime around 1290, when he was yet to become the master of the city. It was not till two decades later, in 1311, that he produced his masterpiece. The nine magistrates—the Nove—ordered trumpets to sound and all shopkeepers

to close their shutters early. Those lucky enough to live on the designated route hung their most valuable drapery out of the windows and leaned out their hopeful faces to catch a glimpse of the passing wonder. The streets were lined with people. Even the officers, the magistrates and the city's dignitaries turned up for this event of deep state importance. Duccio di Buoninsegna, the city's greatest artist, had just completed his enormous Maestà, an epic altarpiece made up of several panels. Over the centuries some of these panels were removed and dispersed, but originally, on the day it left Duccio's studio, the painting measured about 6 × 6 meters. There had been a great buildup. It was all that the Sienese had been talking about for days. The work had been commissioned three years earlier by the city. Outside the artist's workshop, on Via di Stalloreggi, the painting was carefully mounted on to a cart and paraded up Via Banchi di Sotto; then it turned into the Piazza del Campo, before going back and turning right into Via del Capitano, to finally arrive at the Piazza del Duomo, where it was met by priests and monks. All along it was shepherded by the artist, his assistants and apprentices. How astonishing it must have been to be present, to be among those seeing it for the very first time. The painting was so dazzling in its color and realism, and so exceptional in its narrative power—at once reverent of Mary and the Apostles but also unapologetically direct in its fascination with their common humanity, their earthly psychology and emotional life-that it caused the city of Siena to reverberate with a profound depth of feeling. People followed it in silence and awe, carrying candles, praying that Duccio's accomplishment would help to spare their

beloved city from every misfortune. A great emotion, both of faith and solidarity, at once private and unifying, captured everyone. It is hard for us today to imagine the power such imagery had in that age. In the almost pictureless world of that time, such pictorial representations moved and consoled believers, assuring them that they were not only among the faithful but also those who imagined and, by doing so, had actually seen the holy and the sacred. The Maestà is today housed down the road from the Pinacoteca, at the Museo dell'Opera del Duomo, close to where I had met the Nigerian woman. But I did not want to see it just vet. All I wanted now was to be with this earlier, humbler miniature, in which the Virgin Mother's dark gown carves a sort of secondary domain into the middle space, as though she were a doorway on to another reality, or else unveiling a private space, one containing the very quality of her existence, its desolate vulnerability, which is contrasted here with the strength of her great son, who, although still a child, is already aware of the weight and power of his being. The three Franciscan friars at the Virgin's feet appear as one man caught in motion, descending from a position of prayer to kiss Mary's foot, like an early slow-motion film. The child, like all children, has already been initiated into the language of punishment and forgiveness. He understands the friars' plea for mercy and his mother's good ability to give it. And the mother, who can read her son's thoughts, is fortified and persuaded by his verdict. This unites the pair in a reciprocal scheme. They are seduced by one another's dominance. This, together with their languid repose, set so starkly against the friars' urgent appeal, makes them

seem even more confident and authoritative. But the whole plot is undercut by Duccio's sly suggestion, which he introduces through the arid stillness of the Virgin Mary and baby Jesus, that there is something mildly premeditated about the two. They believe that they know more than most, or perhaps more than all, about the transactional power of blessings. And this, strangely, confines them to their fates. Predestiny here is not so much a theological as a psychological condition.

I wondered how I would have looked at this painting had I been Christian. Perhaps I would have liked it less, or liked it more, or liked it in a way that was beside the point, to do with its religious symbolism, and I would have then thought that that was the point, that that was why it had sustained my interest, and I might have been moved and delighted in a subtly but profoundly different way. Or, then again, if I had been a Christian who had outgrown or for whatever reason turned away from my faith, it might have irritated me, brought back bad memories, reminded me of what I would rather forget. It might then have seemed to belong to the oppressive system that I had denounced or simply left behind in the way modern people do, dusting religion off their shoulders without much ceremony and without, even, the need not to believe. In this scenario, the painting would have surely come with its own catalogue of other images and smells and voices, perhaps even the faces and hands of people I had grown up knowing. And if this were the case, how peculiar it would have seemed that such a person as myself, coming from a different tradition, should be so absorbed by these pictures as to leave his wife and home to do little else apart from look at them in a city where he knew no one. I might have then seen it, within the competitive language of sibling faiths, as confirmation of my truth. By the same token, a Muslim might have thought it suspicious, perhaps even disloyal, that I would be so taken by such iconography. To be from one of the Abrahamic faiths, to have been born into one and come of age in the culture of another, and in this time that has for so long now been invested in the confrontation of these traditions, often too concerned with narrow distinctions, with condemnations and illmotivated comparisons, with the logic of discrimination and the lexicon of fear, as though the point of history were to prove ourselves correct, more God-loving, more true or more human, as though spirituality were not the private realm of the heart but rather a race to the finish line where a smiling god would hand out the medals—all this, as I stood in the Pinacoteca, seemed beside the point.

The interesting thing is that all the while I looked at the *Madonna dei Francescani* none of these things occurred to me. Instead, I was the mother, the child and the friar. I felt the painting was painted specifically for me and as though by a brother, not only because Duccio, like all men and women, is a fellow human being, but also because it was obvious to me that he did not intend his picture to be approached from a place of affiliation or allegiance, but rather from the simple position of being human. This is an essential part of the power of the *Madonna dei Francescani*. It is far more interested in human life than it is in God.

THE PROBLEM WITH FAITH

I RETURNED TO THE PALAZZO PUBBLICO. THIS TIME I did not have Lorenzetti's *Allegories* in mind but rather the chapel, where every surface—every centimeter of floor, wall and ceiling space—has been covered in a pattern or a painting. It was added in the fifteenth century and therefore at least some seventy years after Lorenzetti's Sala dei Nove frescoes, which is to say after the world had undergone a momentous transformation. Notions of life and death were forever altered. A shadow had fallen and has remained here with us ever since, affecting all sorts of human enterprises, perhaps the greatest of which is the imagination.

In this time, Sienese art experienced a complete conversion. In fact, the entire history of art and thought and philosophy had taken a turn, and all this was caused by a single event that took place in 1348, a decade after the *Allegory of Good Government*. Lorenzetti was still very much at the height of his powers by then. Earlier that year

he, like most of the inhabitants of European and Middle Eastern cities, began to learn of rumors coming from the Eurasian Steppe, stories of horrific suffering and death, of entire districts being extinguished in a matter of days, cities ravished. The reports were as incredible as they were impossible to ignore. They told of people who had been only moments before in perfect health suddenly and inexplicably dropping dead. The numbers were so high that corpses had to be abandoned, left as though they had fainted in the middle of the street. Pavements became storage grounds for the dead. And the contagion was quickly spreading. No one knew its cause and no remedy had proven to have any effect. The mystery was so complete that several wild theories were already in circulation. One maintained that a distant earthquake had cracked open the earth, causing an ancient virulent infection to escape from the belly of the planet. Another had to do with bitter spirits who had returned in order to exact their final revenge on the living; or, as the more hopeful version had it, the dead had come back not for revenge but rather out of longing, to claim those they loved and take them along to the everlasting place. Whatever the cause, one thing seemed certain: it was the end of time.

The Black Death, which is what the plague came to be called on account of the dark blotches that appeared on the skin of the infected, traveled across continents with astonishing speed, certainly much faster than news of it ever could in the fourteenth century. It moved at such a pace, and the ferocity of its assaults was so stunning, as to make one wonder if the pestilence were not a tactful and thinking intelligence, one constantly plotting how to confuse

and overwhelm its victims. But, of course, it had no consciousness, no ill motive, but rather advanced with outrageous indifference, doing its own good work for its own good end, unthinking, dispassionate, neither concerned with the possibility of defeat nor elated by its conquests.

Some of the bewilderment that the Black Death had inflicted remains with us even today. We are still not entirely clear what precisely had caused it or provoked its numerous reoccurrences over the ensuing centuries. The abiding theory has been that a ravenous parasitic flea, having entirely destroyed the rat colony, went in search of humans. But a newer one has it that the disease could never have spread so quickly had it relied chiefly on rats; it was much more likely that a human parasite—fleas or lice—had been responsible all along. This parasite would have been both adroit and mobile, riding with its host, infesting clothes, entering houses and boarding ships. It is thought that was what gave the epidemic its peculiar swiftness and agility. But this alone cannot explain its staggering pace, and, although scientists and historians today know much more about the events of that deadly year, gaps remain in our knowledge of what exactly took place. We still do not completely understand, for example, how the Black Death traveled from the Eurasian Steppe to the Middle East, North Africa and Europe, then further north to Scandinavia, before circling back east to Russia, surviving all the various climatic variations that occur across such a wide geography and range of terrains. In just over a year it had conquered the known medieval world, reducing the population of each country by an average of 45 percent.

Passing through Damascus, the Moroccan author Ibn Battuta was stunned by what he saw in the Syrian capital. In a matter of days Damascus went from being the cultivated, prosperous and boisterous city that it was then to a place of horror and paranoia. He describes how at one point at the depth of their despair the Damascenes began to gather at the capital's Great Mosque "until it was filled to overflowing." I was a boy when I first read this account, coming upon it in Ibn Battuta's marvelous book A Gift to Those Who Contemplate the Wonders of Cities and the Marvels of Traveling, which chronicled his adventures around the world. I adored it with a passion, but I remember clearly how upset and deeply affected I was by his description of Damascus under the plague. Lying in my room, I kept picturing the people of that city packed in the Great Mosque, praying in silence. At certain moments, I imagined, the imam must have chanted appeals to the Divine in that beautifully melodious Damascene way I sometimes heard on the radio and that had, on one occasion, moved me to tears, and then I heard the assembly repeating after him each line in unison and with great emotion. I saw them sitting in lines, thighs touching, spilling out of the mosque, very much as when, long ago on religious holidays, my father and I would turn up late to prayer and had to spread our mats on the tarmac under the sky. Ibn Battuta describes how, in order to gain God's favor, the Syrian worshippers fasted for three successive days, then one morning, after performing the dawn prayer, they left without even collecting their slippers, marching together barefoot in the early light, at that hour when the sky was lit but the sun had yet to appear, "carrying their

Quran in hand." At every street they passed more people joined them, until it seemed the whole city was marching. "Jews went out with their book of the law and Christians with their Gospel... all of them in tears... imploring the favor of God through His Books and His Prophets."

For Ibn Battuta's fellow North African, the Tunisian historian and historiographer Ibn Khaldūn, the main concern had to do with the changes the Black Death had inflicted on human society:

Civilization both in the East and the West was visited by a destructive plague that devastated nations and caused populations to vanish. It swallowed them up . . . and wiped them out. Civilization decreased with the decrease of mankind. Cities and buildings were laid waste, roads and way signs were obliterated, settlements and mansions became empty, and dynasties and tribes grew weak. The entire inhabited world changed.

It is hard not to read in these words Ibn Khaldūn's own private lament. The Black Death came when he was seventeen and it took from him his father and mother. When he writes that "The entire inhabited world changed," he seems to mean that both sociologically as well as personally; it is a statement that shines a light into two opposite directions, out on to the world and back into the self.

Thinking about Ibn Khaldūn here in the chapel of the Palazzo Pubblico, where I stood surrounded by Taddeo di Bartolo's depictions of the death of the Virgin, pictures concerned with the end of things, a register not central to

Sienese art up to then, I wondered if, as that terrible event had determined the art of the chapel, it had not also played a role in the strange habits that would afflict Ibn Khaldūn's adult life: the way he changed employment and employer with dizzying rapidity, occupying, in a short period of time, a variety of administrative roles and high-ranking state positions, including at one point serving as Prime Minister. He led, and rarely with an obvious purpose. wildly testing and punishing expeditions, and was more than once kidnapped by nomads, who held him captive for several days and then released him stripped of all of his belongings. He had moved from Tunisia to Morocco, from Granada to Seville, then back again to Morocco, before returning to Granada. All the while he taught and studied. He constantly fell out with patrons, allies and colleagues. His relentless mobility continued until he settled in Algeria, where his nervousness was quietened by the book he now wanted to write, a comprehensive history of the Arabs and the Berbers. But, he decided, before such a task could be undertaken, he must first produce, by way of an introduction, a philosophy of history. It is ironic that the great mind's most striking achievement was this extravagant introduction, which he wrote and kept on rewriting in order to open another book. The magnificent Introduction, which itself evolved into a series of books, was to become his masterpiece. Ibn Khaldūn is like a man who arrives at the palace of infinite rooms but gets distracted by the garden. The palace, which he eventually enters, was his planned work, but the Introduction was the garden, a philosophical text on the historical method, on how to write a history, how to distinguish truth from error and

how to locate, observe and analyze consequential turning points in the human story. The twentieth-century Syrian scholar Sāti' al-Husrī describes the Introduction as "a general sociology," one concerned with society, politics, urban life, economics and knowledge. Ibn Khaldūn's peripatetic energy, which up to then had expressed itself in a violent restlessness, troubled relations and a propensity for subjecting himself to great risks, now turned into a rare and precious discipline. His witnessing of the tragic events of the Black Death—its at once universal reach and personal affront—had allowed him to glimpse the possibility of the end of things and perhaps, in so doing, he had resigned himself to writing a beginning, one that, like all introductions, is predominantly concerned with how to start, with the redemptive possibility of being continuously initiated into something new, so that its scale and nature may be understood. It is a plan of action that is overtly worried about erasure. The plague, Ibn Khaldun writes, "overtook the dynasties at the time of their decrepitude, when they had reached the limit of their duration." According to him it was not the wrath of God, as Taddeo di Bartolo and his fellow European Christians believed, that had brought on the plague, but rather that human civilization had grown weak. Ibn Khaldūn's was a pre-Darwinian Darwinian view, and he wanted to see the opportunities in the tragedy. To him it made life seem "as if it were a pristine and repeated creation, a world brought into existence anew." This helped him to uncover a new field of study: sociology. According to the English historian Arnold J. Toynbee, Ibn Khaldūn contributed a "philosophy of history which is undoubtedly the greatest work of its kind that has ever yet been created by any mind in any time or place." I wonder if this would have been possible had the Black Death never occurred.

Lorenzetti, still safe in Siena, learned that Sicily had fallen. It was obvious now that there would be no escape. Fear and hysteria echoed throughout the city. Some ran into the countryside, while others, believing themselves safer inside the metropolis, rushed to enter through one of the nine gates that surround Siena like open mouths. The whole city began to feel like a diseased body gasping for life. The painter, along with his family and apprentices, remained within the city walls.

The Sienese, like their medieval European Christian counterparts, suffered under the conviction that all diseases came from God. They took the Black Death as proof of their guilt. In William Langland's Piers Plowman, a Middle English narrative poem from the time, a work that was to bear an influence on Chaucer's Canterbury Tales, the matter is put succinctly: "these pestilences were for pure sin." The Black Death was therefore ordained and just. The Tuscan poet Petrarch writes from neighboring Florence, "Oh happy people of the future, who have not known these miseries and perchance will class our testimony with the fables. We have, indeed, deserved these [punishments] and even greater; but our forefathers also have deserved them, and may our posterity not also merit the same." The Church encouraged this supernatural explanation. Many priests refused to bless the infected. Most of the believers devoted themselves to prayer and penitential practices, repairing churches and setting up religious houses. The papacy became more powerful—in material

wealth as well as in cultural and psychological terms. Fanaticism was on the rise. One had either to surrender or to rebel.

The need for scapegoats became irresistible: Jews, Muslims in Spain, lepers and other outcasts were regularly attacked. The situation became far worse for Jews when a group of them confessed under torture to some fanciful plot to infect the wells. Indeed, the effects of the Black Death in Europe were in some ways like those of a civil war—like those very civil wars taking place at this moment in Syria and Yemen and, on a smaller scale, in my own country. The plague in Europe provoked violent sectarianism and social division. I had retained an image from one of Petrarch's letters in which he describes some of the effects of the Black Death, which he witnessed: "houses were left vacant, cities deserted, the country neglected, the fields too small for the dead and a fearful and universal solitude [was] over the whole earth." As in today's civil wars, the plague gave criminal groups an opportunity to dominate. In Siena they looted the deserted houses and robbed the living. The city began to resemble Lorenzetti's The Effects of Bad Government. And there was that other picture that had also made its way into my mind and for some reason remained there: "All the citizens did little else except to carry dead bodies to be buried . . . they took some earth and shoveled it down on top of them; and later others were placed on top of them and then another layer of earth, just as one makes lasagne with layers of pasta and cheese." Even when I had first read this all those years ago, it did not sound like Petrarch, it did not have his register, and yet I had persisted to erroneously attribute those words

to him. The peculiar image, back then and well before the revolutions and the wars, did not ring true. Its close juxtaposition of food and death, of play and burial, of nourishment and a mass grave, made it seem gratuitous. It made me think less of Petrarch. And now after discovering that the quote indeed never belonged to him, its lines continue to live with me, their weight and meaning growing over time. Perhaps because my consciousness in the interim had been altered, imprinted with my own images of mass graves, not ones from history but from the present. Today it has become impossible not to consider the idea of mass burials. And it turns out that they are more than they appear. They are motivated by expediency, obviously; but one could think of other, easier ways to get rid of the dead. There is the sea—but that is some distance from Siena. There is the alternative of fire: hygienic and almost automatic, in the sense that one could light the match and walk away, not even needing to look back. But something about the history of putting to rest or disposing of large numbers of bodies has favored the earth. Maybe there is more to it than just convenience. Perhaps the word is what is tempting; after all, "to bury" is also to deny, to attempt to make something disappear. An individual may be honored by a dignified burial, a handsome headstone, but once you get into the large figures of twenty or a hundred—or, as in the case of Abu Salim Prison in Tripoli, where, under the orders of the Qaddafi dictatorship, on June 29, 1996, and in the space of minutes, 1,270 political prisoners were executed and buried where they fell in the prison yard—things become complicated. The act then becomes one concerned with satisfying at least two

conflicting objectives: to make the evidence disappear but also to gather it in one location, thereby making it more effective and augmenting the scale of the accomplishment. And perhaps some fragile but still burning virtue in the mind of the executioner, who is also at that moment the survivor, is strangely consoled by the fact that these disorderly bodies, now jumbled one on top of another, are at least not going into the depths alone.

Some in Europe did rebel. To them the sudden and unexplained dominance of the plague was final proof that the Divine was neither good nor merciful. They claimed Thucydides as their guide, vowing "to get out of life the pleasures which could be had speedily and which would satisfy their lust." They got drunk, stole what they needed and fornicated wildly without inhibition. A London reporter wrote, "In one house you might hear them roaring under the pangs of death, in the next tippling, whoring and belching out blasphemies against God." From here on European Christianity and culture were altered. It was as if Europe had woken up and discovered it had all along been living in the kingdom of death. It wanted this to be expressed in art. It feared forgetting. It trusted in that fear, and wanted to communicate and propagate it. The plague had traumatized the imagination. Everything became stained with guilt.

Similar responses of hedonism and spiritual culpability did occur in the Muslim world but only on the margins. The main response was a deterministic one. Muslims viewed the epidemic as a calamity no different from a storm or a flood, one to be resisted and endured. It was not sent by an angry God but rather decreed by fate, which

governs the order of things. No one was to blame and, as in Ibn Battuta's account of Damascus, people of different faiths often found comfort and solace in solidarity. Yet a doubt from then on grew about the extent to which human beings could shape their future. Faced with the specter of death, both Arab and European societies became more vulnerable to fatalism. Their imagination and the very structure of their values shifted. This is why Albert Camus was interested in the plague. He trusted its extremity. He had faith in its power to illuminate human nature, to expose it, as though it were a masked figure whose true character was mysterious. What Camus feared most and was also most fascinated by is the utopian. The curse of the world, he believed, is the idealist. One could no better reason with an idealist than with a plague.

The Black Death continued periodically rearing its head around the world across the following four to five centuries. The last recorded occurrence in Europe was in 1720. The Balkans and the Middle East endured spells well into the late nineteenth century, and it is thought that the pestilence that devastated India then was a latent relative. It is impossible to discern the overall numbers lost. What is clear is that the Black Death of 1348 was the most devastating incident in human history. It claimed more lives than any other single event. It shaped our attitudes to death and dying and, by implication, to life and living. The flowering of the Renaissance and the Baroque took place in its shadow. Michelangelo, Rembrandt and Vermeer were all periodically threatened by it. It is thought that Titian died of it. And it entered their minds, cast a dye on their thinking, and made death a familiar and inescap-

able guest, the silent companion who will inevitably have the last word. The imagination began to focus on the end of things. "No thought is born in me which has not 'Death' engraved upon it," Michelangelo wrote in a letter to Vasari. Further north in Venice, a city that was particularly badly hit, losing up to 60 percent of its inhabitants. Jacopo Tintoretto painted painfully moving works of suffering and healing dedicated to San Rocco, the saint protector against the plague. In the mid-seventeenth century the Flemish painter Van Dyck moved from the Italian port city of Genoa to Palermo, arriving just as the Sicilian capital was falling victim to a reoccurrence of the plague. Notwithstanding Van Dyck's delicate refinement, he remained and made the horror his subject. For many artists, the sight of death came to seem a rite of passage, a vehement education into the mortal fragility of human life, a window on to the fugitive impermanence of the spirit. Death was the prize. It is behind Nicolas Poussin's landscapes and Auguste Rodin's figures. It is in Dante and Beckett. But perhaps no other artist has wielded the psychological effects of the Black Death, used it so profitably and inventively, and with such relentless force, more than Caravaggio. David with the Head of Goliath derives its power partly from the fact that David knows, regardless of his temporary victory, that he will follow.

After 1348 art changed because man changed. As it entered Siena, one of the first lives the plague claimed was that of Lorenzetti. The pandemic had killed many of his contemporaries too. Gone were their expertise and their ability to train the next generation. Most of the young artists now were without teachers and financial support. The

economy had been devastated and with it private patronage of the arts. The religious fervor inspired by the suffering of so many instilled a powerful commitment to the Church. A few years later, in 1354, the rule of the nine magistrates ended. The clergy now were the principal clients and had a great deal of money and influence on matters of governance and art. They determined what was painted.

The artist who was assigned to decorate the walls of the new chapel in the Palazzo Pubblico. Taddeo di Bartolo. had a big task to fulfill. He needed to revive and carry forth the Sienese tradition as well as reinvent it and make it more adaptable to the tastes of the new patron. Lorenzetti's client was the state: Bartolo's was the Church. He ends up doing something altogether different. It is a performance, and an ingenuous one at that. Through its grandiose certainty, its sheer assertiveness, it manages to satisfy the clergy while at the same time expressing the problem with faith: that faith, any kind of faith, and regardless of how adamant it might appear, is a space of doubt. It was as though Bartolo was echoing that mischieyous statement of Boccaccio's, the Florentine poet and Petrarch's friend and correspondent, who had also witnessed the Black Death and was disturbed by it: "A seemly thing it is . . . that whatever we do, it be begun in the holy and awful name of Him who was the maker of all." An element of that sardonic rebellion was here in the chapel, albeit faintly, perhaps even unintentionally, through the double-edged gesture of assertive magnificence.

THE FIRE

SINCE AS FAR BACK AS I CAN REMEMBER. I HAVE CAUGHT myself imagining the quality of certain known rooms when empty: our old dining room in Tripoli in the house where we lived until I was eight, my current writing studio in London when I am not in it, a close friend's place, much frequented galleries in familiar museums. All the lights are switched off and the curtains drawn, yet the furniture and books and pictures all hold their ground, waiting with an intimate patience, a patience that stares desolation in the eye. I do not know why I do this. But in Siena, where I felt I had arrived at the edge of things, the high-ceilinged rooms of my flat, rooms older than me, older than entire cities elsewhere, seemed to have been always waiting for me. Their atmosphere, which I detected from the very first moment I entered the place, was of that unobservable emptiness I had sought all these years.

I exist mostly to one side of time. Only in rare

moments—for example, when I am with those I love or in times of great exuberance or when I am writing and the work is going well—do I feel in time, that I am where I am meant to be and utterly free from the wish to be anywhere else. The other times have the interference of discord, as though I were detained and that somewhere nearby, possibly in the next street, there is a desired encounter or event taking place, one from which, whether by coincidence or ignorance or bad luck, I am being excluded. The strange thing was that I never suffered this in Siena. Every day and for the entire month I spent there I felt myself to be in time. I woke up at the right moment and left the flat just at the perfect instant so as to encounter everything that unfurled before me. I never rushed or felt myself hurried by anything. Everything I experienced was happening at the pace at which it ought to happen. And at the end of each day, when I returned to the flat, the long. meandering and unplanned walk I had taken remained vividly etched in my memory. I would look at my map of the city, permanently spread on the small table between the two windows, and could trace not only the route I had walked but also all the crisscrossing tangents I had taken off it. It was as though Siena's shape had been imprinted into my mind. All this made me feel I was not so much inside a city but an idea, an allegory that was lending itself, like an old and well-tailored garment, to my needs.

I found something in Siena for which I am yet to have a description, but for which I have been searching, and it came at a resonant juncture: the time between having completed a book and seeing it made public; but also at that strange meeting point of two contradictory events—the bright achievement of having finished a book and the dark maturation of the likelihood, inescapable now, that I will have to live the rest of my days without ever knowing what happened to my father, how or when he died or where his remains may be. That was when I found myself in Siena, in this city that starts and ends so decisively. Every day I walked to its edges—north, south, east, west—and it often felt as though I were tracing the limits of myself. Siena was so varied and consistent, so small and inexhaustible, that it seemed during those days to be endless. It was not only an allegory or a state of mind, but the self as city, modest and particular yet never totally knowable, for it was a constantly moving target, changing with every passing influence and unfolding day.

The days moved with me locked inside this simple routine: I would go to the Pinacoteca immediately after morning class, then walk to one of the edges of the city. For some reason, I no longer wished to return to the cemetery. I saw Adam and his family a couple more times and, having had all my attempts to invite them fail, each occasion was at their home. I held a dinner party for my teachers and fellow students. And apart from that I saw no one. The fewer people I saw, the more engaging the city and the paintings became. Outside of class, I mostly managed not to speak a word. I felt as though I were, with the passing of each day, coming a step closer to a fire. It warmed and delighted but, I somehow knew, was capable of annihilating me. And I suspected, in the silence of those days, that that might be the fire's true desire. So when I saw a

missed call from Beatrice, an old friend—old in time and in age—who lived nearby, about an hour's drive from Siena, I was pleased but also hesitant to return the call. I had deliberately not informed her of my coming here. I knew she would want me to visit and, given how much I treasured her company, I could not be entirely sure how able I would have been to resist. I wanted to keep within the wall. But she found out from another friend that I was in Italy and rang me. Why hadn't I called? And where was I exactly? When I told her she was furious.

"But this is very strange behavior," she said. "You must come at once."

"I can't."

"Don't you know I'm having a party? It wasn't my idea but everyone insisted. I am turning ninety."

"Happy birthday. I'll come at the end of my stay," I said.

"And what, miss the party? But what are you doing in Siena anyway?"

"Looking at paintings."

"You can look at them from here."

"It's not the same."

"But Siena is next door. You can come to the party and go back. Please. It won't be the same without you."

The following morning one of our mutual friends came to collect me. We drove north, then turned into the hills, then went off-road to reach the old and secluded house. It was a familiar place and in every room there were familiar faces. Everything seemed raw and exposed, as though my time alone in Siena had sharpened my senses. A curtain had been drawn. I delighted in being among

friends and acquaintances, in small talk and gossip, questions about what we were going to eat, whether to have drinks indoors or out in the garden. But all along I was aware of a strange distance, a quiet regret, as though I had broken a vow.

IL BAGNO TURCO

PERHAPS EACH ONE OF US CARRIES, ALONG WITH EVERYthing that has happened, a private genealogy of rooms. Somewhere there is a collection of dining tables, a long line of beds, an assembly of chairs, countless doors we have opened and shut, a library of drawers into which we have placed the mundane as well as the valuable. Gathered in some imaginary museum, such a personal architectural inventory might be a compelling portrait of a life or the lives of several individuals, whose trajectories, whether by fate or chance or deliberate intent, had been intertwined with one another as firmly as a vine with a trellis. I thought this as I sat the following afternoon with Beatrice in the most private of rooms, her bathroom. She was sitting in a chair draped with fabric. Beside her was the counter with the two sinks. It was strewn with makeup and perfume. Straddling it were two windows looking into trees. The leaves moved gently, changing the afternoon light. There is something about gently moving shadows that makes me

never want to lift my gaze. This room had been Beatrice's bathroom for over half a century, from well before I was born. The bathroom was on the first floor of the old Tuscan farmhouse that she and her late husband, who passed away a few years before Beatrice and I met, had converted into a beautiful and rambling home. I was on the daybed in the opposite corner. Between us were two white bathtubs sunk into the middle of the floor. They looked like conspiring seashells. The rest of the floor was carpeted in old kilims that she had bought on trips to Kabul and Tunis.

"He used to believe," she said, referring to her late husband, "that the secret to a good marriage is never to share a bathroom. Maybe to share a bedroom, that is a good idea, but never a bathroom."

I agreed and this made her laugh.

"So it was a bit complicated, you know," she said, opening her hand, pointing to the fact that this was also a space in between, connecting with three different destinations: her bedroom, her late husband's dressing room, where, although he departed nearly twenty years ago, everything remained as it was—his shoes, his belts, his silk handkerchiefs—and the corridor that runs to different parts of the upper floor.

"First of all I thought I was going to have . . ." she said and stopped. Her expression changed a little. "Well, I was pregnant. So I thought I would put a child in the room on the other side of the corridor. And it came very naturally that if we could not each have our own bathroom because of the space, then at least each would have his own bathtub. It was his idea. He said, 'Can you imagine how nice it would be to have a discussion like that?' So we built

them facing one another. You can even have a fight or whatever you want."

"And you don't have to negotiate the temperature," I said.

"Exactly," she said. "The things you have to worry about at the beginning of a marriage..." After a short silence she added, "The idea was to preserve the sanity of a married life."

"You never told me about the baby."

"I lost it when it was eight months already. There's nothing to say about it. It was just sad. And he had three children but he wanted, out of curiosity, because the other ones were German—the mother was German—he wanted very much to have an Italian child with Armenian blood. He thought it would be very interesting to see what would be the product of all that. But it didn't happen."

I tried to imagine the life of this child. I became aware of its absence. It bled into all that I knew about my friend and into all the days we had spent together and all the places we had been, as though now beside everything else there was this child's shadow. Such moments, when Beatrice would let me into a dark place, were rare.

"The other strange thing about this bathroom," she continued, "is that you have to walk through it to go see me in my bedroom, to visit me or to bring me . . ." She looked at her dog, a pug. It stood beside her chair, gazing up at her. "Vieni," she told it. Then to me, "She wants to come up to my lap."

I thought if either of us moved the subject too would change.

"Vieni, Rosina," Beatrice said again. The pug became excited. "I have to pull her because I don't think she can . . . She's like me, you see, she has a bad spine." The dog took a step back. "Well, you want to stay there or you want to come, Rosina? She just wants attention. Look at her," she said. "I've never seen a dog sit like that. She's like a human being." Sweetly, as though speaking to a child, she said, "Rosina la pallina, ma non posso continuare. We are having an important conversation here." Beatrice finally picked Rosina up.

"Tell me, weren't you born in Rome?" I asked.

I knew this already but I somehow wanted to keep her talking about the past and to continue watching her across the room, with the twin baths between us, and she sitting and the gentle light spilling in through the two windows behind her. To one side there was her wardrobe, with its doors flung open, as she had yet to decide what to wear for the party.

"There was an architect who invented a sort of a Moresque pastiche in the 1920s," she continued. "He was called Gino Coppedè. And Coppedè did a strange Moorish quarter of Rome and the houses there were at the time very fashionable. My grandfather bought a big apartment in one of those houses. At the time children were born at home, so I was born there."

I knew the district. My father had walked me through it on one of our visits to Rome when I was a child. I remember him pointing out the Arab influence and how proud it made me feel. But I did not tell Beatrice this.

"Are you comfortable there?" she asked.

"Yes." I said. I was looking up at the picture hanging above me: Michelangelo Pistoletto's Il bagno turco, a silkscreen on polished stainless-steel of a woman playing the guitar. She has her back to us. Her flesh is warmly colored. The two dimples at her lower back are sweetly erotic. Her shape suggests antiquity yet she is flesh and blood. You can glimpse the top of her left thigh, covered in an off-white stocking that might be that color from lack of washing, and that is the only part of her that is clothed. She could be from any century except for her wrist and hand, which grip the neck of the guitar as her unseen fingers play some unknown chord. I wondered what it was about her wrist and hand that made them look contemporary. Her head is turned in the opposite direction, perhaps because she is unsure of the effects of her music or worried about being overheard. Her left breast presses against the guitar's back. I wondered if the polished wood felt cold at first, or if it still does, accounting for the curve in her back, which would mean that we are here at the beginning of her performance.

"It's a very friendly space," Beatrice said suddenly, and it took me a second to realize she meant the bathroom.

"It was also for us what the English call 'the angry room.' If we had a little discussion and one of us wanted to get away they could go here. Or if one of us had a cold and was sneezing. It gave us that sort of independent togetherness."

She paused, and for a moment seemed self-conscious. Although she had told me many of these details before, it was always in fragments.

"Oh, but I can't tell you my life in three words," she

said. "It's too long. You'll have to invent it. I would very much like an invented life."

"Me too," I said.

"And what about my dogs?" she said, looking at Rosina. "A dog is wonderful because she doesn't know when you're getting old. Doesn't know you are getting ugly. She thinks you are the best thing in the world."

We sat in silence. Then I asked if she and he had used the bathroom as intended.

"Not really," she said and laughed. "But it was an amusing idea. It was symbolic. We were independent but we needed each other very much. We only occasionally bathed at the same time."

I pictured them lying face to face, separate but together, in the bathtubs that were recessed into the floor, bringing the bathers' eye level to not much higher than a pug's,

from which angle one would be able to see little else but sky through the windows. Two figures who had arrived there through many other bathrooms and countries. A childless couple with the ghost of the child that was nearly theirs hovering somewhere now in this house, the same house where it would have been born.

THE ANGEL'S PREDICAMENT

As reluctant as I had been to leave my cloistered existence and travel to attend Beatrice's party, so it took some exercise of discipline to return to Siena. It was as though whatever I had come to do there had been disrupted. That first night back I had a dream that I have since, and from time to time and for no apparent reason, occasionally remembered in my waking hours, provoked by events or details that I have failed to distinguish. I have never understood why some dreams vanish while others remain indelible like this. Perhaps the dreams we forget are the ones we no longer have a need for.

The dream was of a family living in a large and windowless room. If he, the old man, does not cook supper, then his wife prepares the same meal they eat every night before they turn in: boiled eggs, a plate of tuna and harissa, bread, sliced cucumber sprinkled with salt. The elderly couple have a child, a boy. He is theirs but because of the large age difference does not seem to belong to them

completely. And, notwithstanding his good temperament, the boy has that particular sadness of the children of aging parents. His old father tries to keep up a degree of good cheer on Fridays, when after prayer he takes a small chicken out of the freezer. Half a cup of sugar, another of salt, a splash of vinegar, all mixed in a large pot. He then fills it with warm water and sinks the bird into the brine to clean it, hearing the bubbles escape. The father does all of this with an automatism that conveys the simple pleasure he finds in these steps but also a hesitant regret, some deeply private remorse. What has remained most strongly with me from the dream is not its narrative but rather its frugal atmosphere, the silence that accompanied the lives of these people.

In the morning the city was oddly quiet. I left the flat and walked in a new direction. The streets were empty but then I saw a few people descending a steep incline. I followed them. The street led into a courtyard that led further into a church. Entering after the figures, I found myself in a frescoed chapel with delicate and fading floor tiles. I crossed the passage and opened the church door just wide enough to slip in. The place was packed. Standing room only. A service was in full session. I stood at the back and watched the heads and sides of the faces of some of the members of the congregation. I had completely forgotten that it was Sunday. I left the church and saw a narrow alleyway going further uphill. I took it and it led to a small square that had a wide view back on to the city. I kept going, past another church and further, till I saw runners and walkers heading in a particular direction. I followed them and the road led me to a fort with a continuous ramp—a sort of architectural joke. I sat there for a long while, watching people run in circles.

A few days later I went to the museum at the Oratorio di San Bernardino to see one of the strangest paintings of the Sienese School. Ambrogio Lorenzetti's Madonna del latte is even more outrageous than it appeared in the various reproductions I had seen. It is hard to think of a more unsettling representation of a mother and child. Mary is placid and seemingly vacant as she looks down at her boy with a resignation that brings to mind a trapped servant thinking hard of a way out. There is a cunning quality to her intelligence that seems to be flirting with a cautious and questioning attitude toward her fate. She is not sure she likes this situation. Her veil ropes around her neck and might just be the reason why she has turned toward her child—in other words, it might be motherly love, but it might also be restriction. This makes her embrace as much an attempt to keep the child near as it is, perhaps, to keep him away. Her right hand, which is shelving the boy's left buttock, is oddly doubtful. The fingers of the other hand, which is clasped around the child's small left shoulder, are open and perfectly parallel, like the metal bars of an iron cage. It is with that hand that she nudges the fabric of the sheet he is wrapped in against his ear, muffling the ear that is facing us, which makes the boy's gesture of turning to look directly at us with his sardonically raised eyebrow seem wary and curious, but also rebellious. He wants to know what we are really thinking, and what it is that his mother does not wish for him to hear. He is also

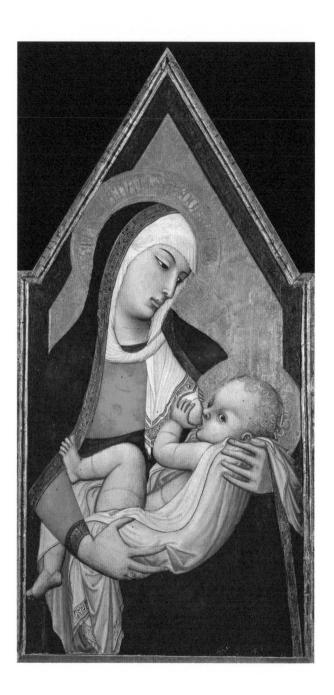

wondering what it is exactly that he is earning from us: admiration or envy; and does not seem sure which he would prefer. He sees no reason why he cannot have both. Like any child caught in public with his mother, he is concerned about his image. But, unlike any other child, this one is aware of his powers and conscious too of the options they give him. His legs are climbing as though he is frightened by our sudden appearance, or perhaps he is desirous of his mother, wanting to claim her further for himself. Either way, there is a sexual quality to his excitement; it has the urge of lust. The little fingers of his left hand are wrapped around his mother's left breast and greedily squeezing it. His right hand looks like it is trying to peel off his golden halo to get it out of the way. His lips have already claimed the nipple, and do so lavishly. He is gorging himself. Under no circumstances is he interested in death. He wants to live and live well. He wants to have it all. This is a child who has no qualms about his appetites. He is as assertive as he is free. His left foot, which presses against his mother's arm, seems to be a rejection of his filial reality. His other foot, the right foot of the child who is to change the world, is testing the painting's frame, threatening to shatter it, to blow the whole picture wide open.

On my way out of the Oratorio di San Bernardino I encountered another picture, one far less consequential to the history of art, but that sustained my attention for the next three days as I kept returning to it. Sano di Pietro's *Angelo annunciante* is a small picture painted on a round wooden tray that the museum houses in a table cabinet. To study it one has to look down, which increases the

painting's intimacy. It is a picture concerned with an angel's predicament. Her state and gaze and posture are all caught inside a contradiction: submissive vet doubtful. concerned yet surrendering. The eyes, loving and melancholy and lonesome, are fixed on the unseen. The cloak is lavish, like a musical gesture of flambovance, twirling around a still figure dressed in a white gown that is the white of infinity: abstract, endless and indifferent. She is a young adult, but her wings have the air of the ages. The crowning curls of her hair are as lush and frail as time. If her locks were weaving an argument, it would be a worldly, anecdotal and intimately elaborate one. I am not sure why but the more I looked at the Angel annunciante the more I felt a deep pain in my chest, as though I were longing for a specific person, a place or a time now forever gone.

PARADISE

I RETURNED TO LONDON. I GRADUALLY REGAINED THE rhythm of my days. But not long after I had settled in I had to go to New York for work. The day after I arrived I met a couple of friends for dinner. She is a human rights lawyer and he is a professor. We met at a place they like. Notwithstanding their optimism, the optimism of successful people, they both at an unexpected turn in the conversation began to confess such inconsolable disappointments regarding their lives and careers, veiled sentiments that seemed to conceal powerful criticisms of one another. Each listed, with the hint of blame and quiet violence that some couples are capable of, all the missed opportunities, the roads not taken, the now uncorrectable regrets.

The following morning I woke up and spent a few minutes searching on my phone for flights back to Siena, wondering how I could possibly escape all my work commitments. I lay naked on the couch looking out of the window. I showered and returned there to dry off in the

breeze. It had been a very warm night. At one point I heard a woman say, "We don't want to get run over," and then she repeated it in a childish manner. I stood, knowing that if she were to turn back and look up she would see a naked man in the window. I watched her run nervously with her two children, a boy and a girl, across an entirely deserted street, no cars in sight.

I got dressed and walked to the Metropolitan Museum of Art. I wanted to see *Paradise* by the Sienese painter Giovanni di Paolo, painted around 1445, nearly a century after the Black Death. I found it quickly and without consulting a map or asking an attendant. The painting was much smaller than I had anticipated. I had not cared to read its measurements in the online description. My impression was that it would be as tall as a ten-year-old child, but in fact it was small enough to wrap in a newspaper. Its surface was rough and cracked.

The painting imagines a reunion in the hereafter. According to di Paolo, such a reunion would take place in twos, with each person facing the other, holding hands. The pairs are arranged in a sort of waltz in three horizontal rows: six couples on the top, four in the middle and four on the bottom. The picture is organized vertically, as though the earth has become a façade. All values are equally represented and none diminish into a realistic perspective. Right at the top there is a glimpse of the horizon, curving innocently, and a row of apple trees fencing the sky. They are heavy with fruit. Now that we have gone full circle, the painting seems to say, the eating of apples is not only permitted but also encouraged.

What is it for the dead to remember the living, I

wondered, to still be able to recognize those we knew when the soul was flesh. The saintly are greeted and welcomed by angels; even their reunion is ecclesiastical. Then there are men and women, like the spouses buried together in the cemetery in Siena, holding hands and looking into each other's eyes. This surely is the way to be, I thought to myself, that one should take hold of those one loves most and simply look into their eyes for a long time or, perhaps, for eternity. Other pairs seem to be the same person but at different stages of life: the older-self greeting the younger. Only one couple, a nun and a monk at the bottom-righthand corner of the frame, is accompanied by a third person, a younger nun who seems to be restraining the older one. She has her arms wrapped around her as though trying to stop her from greeting the approaching monk. Could it be Héloïse and Abelard, the lovers who could love only from a distance? They had preceded di Paolo by some three centuries. I was sure he would have read their letters and known of Abelard's desperate plea against writing, claiming it is a "disease." Héloïse, on the other hand, was not bothered by transgressions. She, instead, was interested in appearance and disappearance. "We are much fonder of the pictures of those we love, when they are at a great distance, than when they are near to us," she writes to him. "If the portraits of our absent friends are pleasant to us . . . how much more pleasant are letters." And she is wonderfully greedy when she asks him, "Let me have a faithful account of all that concerns you."

That must surely be the ambition of every reunion, not only to identify and be identified, but also to have an accurate account of all that has come since the last

encounter. And it must surely follow that what lies behind our longing and nostalgia is exactly this need to be accounted for. It is as if what di Paolo is thinking here is that a true hell is not the hell of fire but of not being recognized by those closest to us. We want to be seen by them and, in turn, rediscover our own powers of remembrance, and to finally find the consolation that lies between intention and expression, between the concealed sentiment and its outward shape. The painting understands this. It knows that what we wish for most, even more than paradise, is to be recognized; that regardless of how transformed and transfigured we might be by the passage, something of us might sustain and remain perceptible to those we have spent so long loving. Perhaps the entire history of art is the unfolding of this ambition; that every book, painting or symphony is an attempt to give a faithful account of all that concerns us.

When Diana joined me in New York, we spent several days hardly seeing anyone else. We went to the Metropolitan Museum of Art a couple of times, but on each occasion I wanted to see what she wanted to see. It was only two or three weeks later that I spoke to her of *Paradise*. I took her to see it and for the next three months we spent in the city we returned to it almost every week. We looked forward to these visits, as though we were going to see an old friend.

IMAGE CREDITS

..... 0

The Hading of the Man Rom Blind by Duccio di

puge o	Buoninsegna, 1307/8-11: National Gallery, London. Photo courtesy of The National Gallery.
pages 18–19	Allegory of Good Government by Ambrogio Lorenzetti, 1338: Palazzo Pubblico, Siena. Photo courtesy of Alto Vinto Images/Alamy Stock Photo.
page 24	"Arabic-Sienese Man," detail from <i>Allegory of</i> Good Government by Ambrogio Lorenzetti, 1338: Palazzo Pubblico, Siena.
page 33	David with the Head of Goliath by Michelangelo Merisi da Caravaggio, 1610: Galleria Borghese, Rome.
page 35	The Triumph of David by Nicolas Poussin, 1631-3: Dulwich Picture Gallery, London
page 41	"Peace," detail from Allegory of Good Government by Ambrogio Lorenzetti, 1338: Palazzo Pubblico,

pages 46-47 "The Country," detail from The Effects of Good Government in the Country by Ambrogio Lorenzetti, 1338: Palazzo Pubblico, Siena.

Ltd/Alamy Stock Photo.

pages 44-45 The Effects of Good Government in the City by Am-

brogio Lorenzetti, 1338: Palazzo Pubblico, Siena. Photo courtesy of Heritage Image Partnership

Siena

- page 49 "Tyranny," detail from The Effects of Bad Government by Ambrogio Lorenzetti, 1338: Palazzo Pubblico, Siena.
- page 51 "Justice in Chains," detail from The Effects of Bad Government by Ambrogio Lorenzetti, 1338: Palazzo Pubblico, Siena. Photo courtesy of The History Collection/Alamy Stock Photo.
- page 85 Madonna dei Francescani by Duccio di Buoninsegna, ca. 1300: Pinacoteca Nazionale di Siena. Photo courtesty of Leemage/UIG via Getty Images.
- page 113 Il bagno turco by Michelangelo Pistoletto, 1971:
 Museum of Contemporary Art Chicago. Nathan Keay's photograph courtesy of the Collection,
 Museum of Contemporary Art Chicago.
- page 118 Madonna del latte by Ambrogio Lorenzetti, ca. 1330: Oratorio di San Bernardino e Museo Diocesano d'Arte Sacra, Siena.
- page 120 Angelo annunciante by Sano di Pietro: Oratorio di San Bernardino e Museo Diocesano d'Arte Sacra, Siena.
- page 124 Paradise by Giovanni di Paolo, 1445: Metropolitan Museum of Art, New York.
- page 126 "Héloïse and Abelard," from *Paradise* by Giovanni di Paolo, 1445: Metropolitan Museum of Art, New York.

ABOUT THE AUTHOR

HISHAM MATAR is the Pulitzer Prize-winning author of the memoir The Return, which also received the PEN/Jean Stein Award and other international prizes, and was selected as one of The New York Times's Ten Best Books of the Year. His debut novel, In the Country of Men, was shortlisted for the Man Booker Prize and won several awards, including the Royal Society of Literature Ondaatje Prize and a Commonwealth First Book Award. His second novel. Anatomy of a Disappearance, was selected as one of the best books of the year by several publications, including the Chicago Tribune and The Guardian. He was elected as a Fellow of the Royal Society of Literature in 2013. Born in New York City to Libyan parents, he spent his childhood in Tripoli and Cairo and now divides his time between London and New York, where he teaches literature at Barnard College, Columbia University.

ABOUT THE TYPE

This book was set in Bembo, a typeface based on an old-style Roman face that was used for Cardinal Pietro Bembo's tract *De Aetna* in 1495. Bembo was cut by Francesco Griffo (1450–1518) in the early sixteenth century for Italian Renaissance printer and publisher Aldus Manutius (1449–1515). The Lanston Monotype Company of Philadelphia brought the well-proportioned letterforms of Bembo to the United States in the 1930s.